MW00608028

IMAGES
of America

NEWBURY

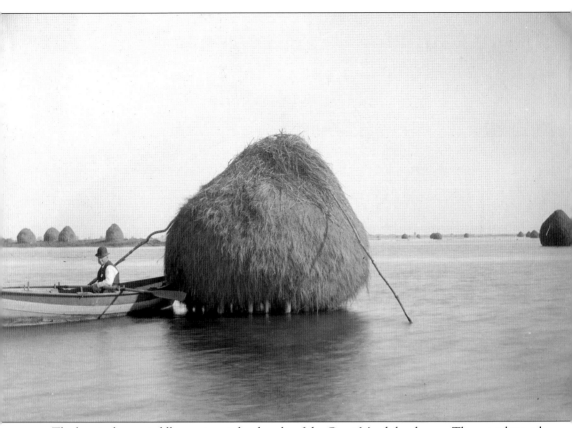

The haystacks on staddles are iconic landmarks of the Great Marsh landscape. The cut salt marsh hay is raked into mounds and stacked on wooden supports to keep it dry above the high-tide mark. The stacks are often 20 feet high and can weigh as much as two tons. (Courtesy of Historical Society of Old Newbury.)

ON THE COVER: This c. 1900 photograph with its placid view of the Parker River shows passengers awaiting a ride on the steamboat *Cygnet* at the Newbury Town Landing. (Courtesy of Historical Society of Old Newbury.)

IMAGES
of America

NEWBURY

Historical Society of Old Newbury

ARCADIA
PUBLISHING

Copyright © 2018 by Historical Society of Old Newbury
ISBN 978-1-4671-2893-3

Published by Arcadia Publishing
Charleston, South Carolina

Printed in the United States of America

Library of Congress Control Number: 2017958528

For all general information, please contact Arcadia Publishing:
Telephone 843-853-2070
Fax 843-853-0044
E-mail sales@arcadiapublishing.com
For customer service and orders:
Toll-Free 1-888-313-2665

Visit us on the Internet at www.arcadiapublishing.com

*To Ruth A. Yesair, who has worked tirelessly to
record and preserve the history of Newbury*

CONTENTS

ACKNOWLEDGMENTS

We are grateful to the numerous people who have made this book possible. The Board of Directors of the Historical Society of Old Newbury has supported the project from its inception. All of the images come from the society's collections unless otherwise noted. We owe heartfelt thanks to the Governor's Academy, the Fernald family, Elizabeth Armstrong, Eva Jackman, and Donald Quill for providing photographs from their collections.

I owe a tremendous debt of thanks to my coauthors, Elizabeth Armstrong, Alexander Burke, Eva Jackman, and Nancy Thurlow, for their vast knowledge of Newbury and for their insights, memories, and stories. Their contributions have made this book a richer volume.

Historical information was gleaned from numerous sources, including *Images from the Past 1635–1985 Newbury, Massachusetts*; *Newbury Reconnaissance Report, Massachusetts Heritage Landscape Inventory Program*, prepared by the Massachusetts Department of Conservation and Essex National Heritage Commission; *Plum Island the Way It Was*, by Nancy Weare; *The Story of Byfield*, by John Elwell; and the Newbury Historical Commission.

Special thanks are due to Emily Shafer, assistant director, and intern Hannah McIsaac of the Historical Society of Old Newbury for their invaluable assistance in making this book a reality.

—Susan C.S. Edwards
Executive Director

INTRODUCTION

Newbury is among the earliest settlements in Massachusetts, having been settled and incorporated in 1635. During what has become known as the Great Migration, the ship *Mary and John* set sail in March 1634 from Southampton, England, and arrived in Dorchester, Massachusetts, in May of that year. The new colonists made their way to Ipswich and wintered over there before traveling by water next spring to arrive in Newbury along the banks of the Parker River. Among the group were the Reverend Thomas Parker and the Reverend James Noyes, who ministered to the settlers in a meetinghouse very near the landing site on the Lower Green. The first settlement grew up around the green, with house plots being marked off. Unlike many of the first Massachusetts colonists, the Newbury men and women were not seeking religious freedom. Many were livestock investors hoping to establish a prosperous agricultural enterprise. One hundred and fifty years later, nearly 3,000 cattle grazed on the town lands and on the nearby salt marshes.

Originally, Newbury was comprised of five parishes, but after Newburyport was set off in 1764 and West Newbury in 1819, only the First Parish and Byfield Parish remained. Old Town, which includes the First Parish, stretches along the banks of the Parker River and Little River and consists of pasture, upland, and marsh, giving it a rich diversity of landscape. The primary road was the High Road, running north and south, and today it is designated a Massachusetts scenic byway. For generations, Old Town has been captured by American artists such as Martin Johnson Heade and Alfred Thompson Bricher, whose evocative paintings of the Great Marsh stand as a testament to this compelling landscape. This is quintessential New England, which has let time pass it by.

Byfield, west of the Parker River, became the industrial hub of Newbury. The first textile mill in the United States started production at the Central Street falls on the Parker River. Other industry followed in the form of sawmills, gristmills, tanneries, and two snuff mills that continued operation well into the 20th century. The most exotic of those early industries was silver mining when a vein of silver was discovered in 1874 and was worked through 1879. The mine opened again in 1919 and closed for good in 1925. During this brief period, the mine yielded half a million dollars in silver.

The other commanding presence in Byfield is the Governor's Academy, the oldest private nondenominational boarding school in the country. Established in 1763 as Governor Dummer Academy, the school was the result of a bequest in William Dummer's will. He also gave the sprawling Dummer farm for the location of the school. Byfield Parish boasts the site of the first female seminary in the United States, which was founded in 1807. Mary Lyon, who was among its students, went on to found Wheaton College in 1834 and Mount Holyoke College in 1837.

Plum Island, a nine-mile barrier beach, stretches the length of Newbury and is shared by Newburyport to the north and Rowley and Ipswich to the south. The beach and sand dunes are separated from the mainland by the Plum Island River and salt marsh.

The first record of Plum Island was in 1614, when Capt. John Smith included it on a map of New England. In the 17th century, the island provided summer habitation for local Indians. In the

18th century, much of the island was used for grazing for the colonists' livestock. The harvested salt hay was used for animal fodder and bedding. By the 19th century, Plum Island had become a popular place for birding and hunting, and by the 1880s, families began building rustic cottages along the shorefront. The advent of the railroad mid-century brought more visitors to the area, and as a result, Plum Island blossomed into a fashionable Victorian summer resort with several hostelries and places of entertainment such as dance halls and pavilions.

During the first half of the 19th century, dozens of ships were lost due to the treacherous conditions for vessels entering the mouth of the Merrimack River. Loss of human life, as well as cargo, was devastating. In 1871, the federal government took action by establishing the Life-Saving Service. The brave men who were stationed at Plum Island served under desperate conditions to save innumerable lives.

Old Town and Byfield have an abundance of historic homes; some were lost to fire or the ravages of time, but many remain standing and have been designated national historic landmarks. Four have been preserved by Historic New England as museums. These are the Spencer-Pierce-Little Farm, the Tristram Coffin House, the Swett-Ilsley House, and the Dole-Little House.

Equally as distinctive as the built landscape are the glacial erratics, including Devil's Den, and other natural features such as Old Town Hill, a 168-foot promontory with a commanding view of three states and vistas of salt marsh, tidal creeks, and pastureland. Old Town Hill is a link in the Bay Circuit Trail and is a property of the Trustees of Reservations.

Newbury has had its share of famous personages. Among those who had strong associations with the community are Samuel Sewall, chief justice of the Massachusetts Superior Court of Judicature, who played a pivotal role in the Salem witch trials; Jonathan Singletary Dunham, a prominent early settler who has the distinction of being Pres. Barack Obama's eighth-great-grandfather; Theophilus Parsons, chief justice of the Massachusetts Supreme Judicial Court and primary author of the Massachusetts Constitution; William Graves Perry, architect of Colonial Williamsburg; and John P. Marquand, a popular 20th-century novelist who made his home on Kent's Island.

If the first settlers of Newbury were to visit their town today, they would find many familiar scenes—the gently flowing Parker River, the great salt marsh dotted with haystacks, bucolic lanes, giant rock outcroppings, and land tilled for farming. They would even recognize some of the early framed houses built by the first stalwart families. In many respects, Newbury is a town untouched by the centuries.

One

SETTLEMENT

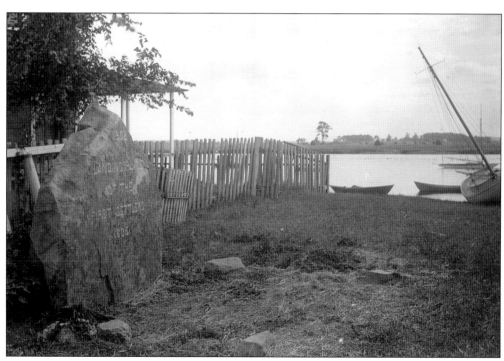

The first settlers to Newbury arrived in May 1635 after wintering over in nearby Ipswich. They came by water and disembarked on the north shore of the Parker River. Legend has it that Nicholas Noyes was the first to disembark from their vessel with a veritable leap on to the shore. The monument was placed at the end of Cottage Road in 1902 with a dedication ceremony attended by many descendants of the first settlers. This photograph was taken around 1905.

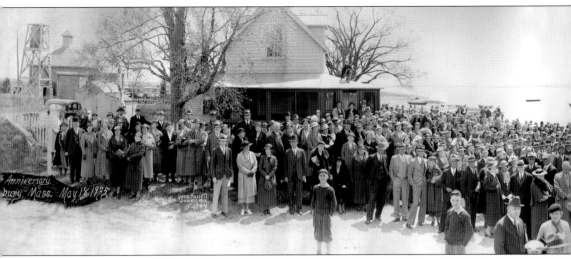

Newbury's 300th anniversary in 1935 was celebrated with a great flourish at the Landing Place and along the banks of the Parker River. These panoramic photographs represent most of Newbury's

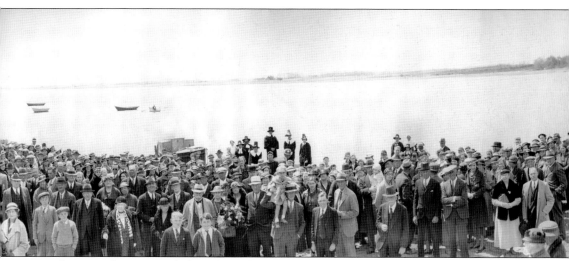

population at the time, including descendants of many of the first settlers. George Russell, who specialized in panoramic photography, was brought in for the event.

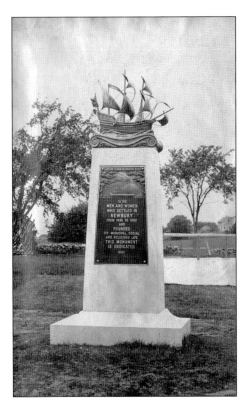

The monument at the Lower Green, dedicated in 1905 and pictured around 1910, celebrates the men and women who settled Newbury between 1635 and 1650. The stone is surmounted by a replica of the ship *Mary and John*, which left southwest England in March 1634 and arrived in Dorchester in May of that year. The Reverend Thomas Parker, James Noyes, and others in the group went to Ipswich, where they spent the winter before arriving in Newbury the following spring. The reverse side of the monument lists many of the early settlers.

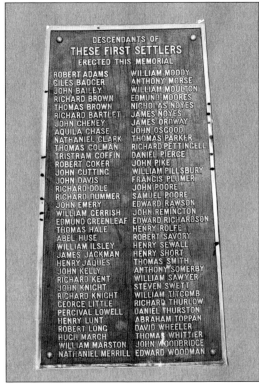

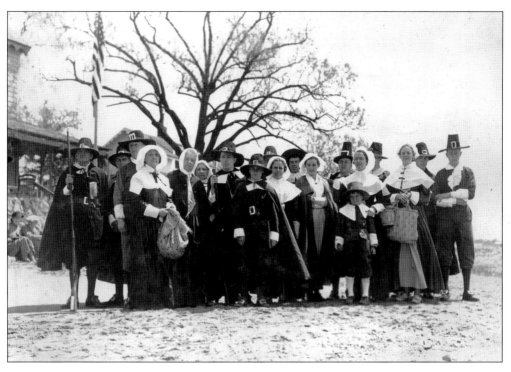

The 300th-anniversary celebrations in 1935 included a group of individuals dressed in Colonial costume who re-enacted the landing by the first settlers. These men, women, and children joined the festivities and sailed along the Parker River. George Noyes took the photographs.

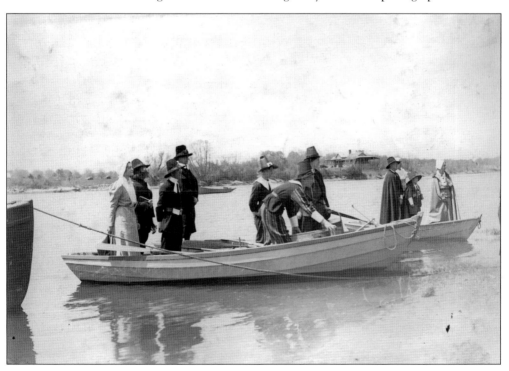

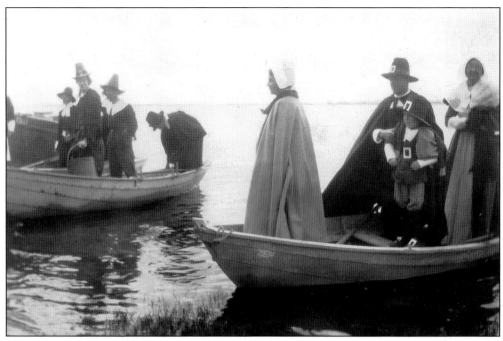

Community members of all ages participated in the 300th-anniversary reenactments on the Parker River.

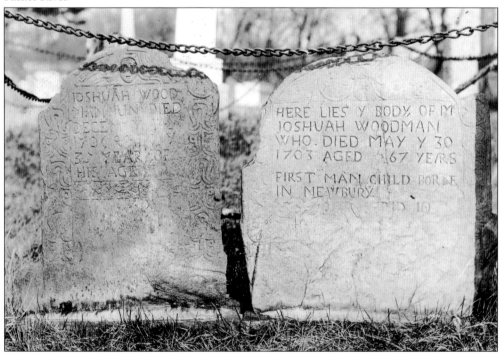

Joshua Woodman was the first male child born in Newbury, to Edward and Joanna Salway Woodman in 1636. In 1666, he married Elizabeth Stevens of Andover. Woodman died on May 30, 1703, at the age of 67. His stone is in the Byfield Parish Burial Ground. The stone to the left is that of his son, also Joshua Woodman, who was born in 1672 and died in 1706.

Two

LANDMARKS
AND LANDSCAPES

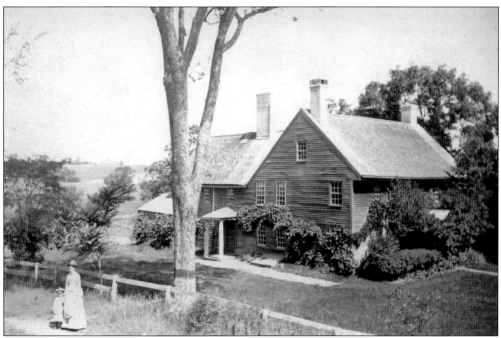

The 1678 Tristram Coffin House on High Road was home to six generations of this Newbury family. Tristram Coffin Jr. immigrated to Newbury with his family in 1643. Coffin married the widow Judith Somerby and built the house in the traditional post-medieval style. In 1705, Nathaniel Coffin took ownership of the house, and he created an addition in 1712. Additions continued as the family grew. In 1785, the house was divided into two residences, and it remained divided until the death of Lucy Coffin in 1893. It is now the property of Historic New England. The house is pictured in 1890.

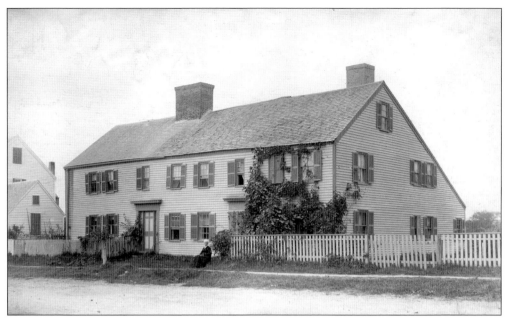

The Swett-Ilsley House is located at 4 High Road. The original portion of this ancient house, one room deep, was built in 1670 by Stephen Swett. Several 18th-century additions more than doubled the size of the house, and it was occupied by the Ilsley family for nearly a century. The house served as a tavern and, at one time, housed a chocolate shop and a chandlery. Historic New England acquired it as the organization's first property in 1911. The house was restored with the removal of 19th-century additions, and fine architectural details were revealed. The massive fireplace below, over 10 feet wide and with three beehive ovens, is one of the largest in New England.

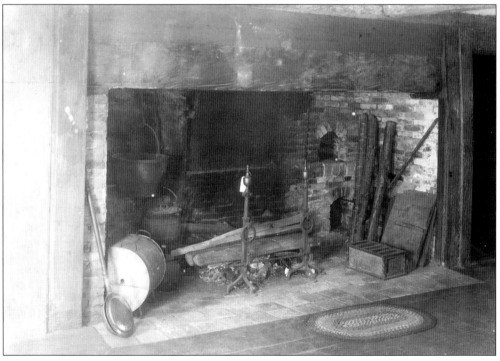

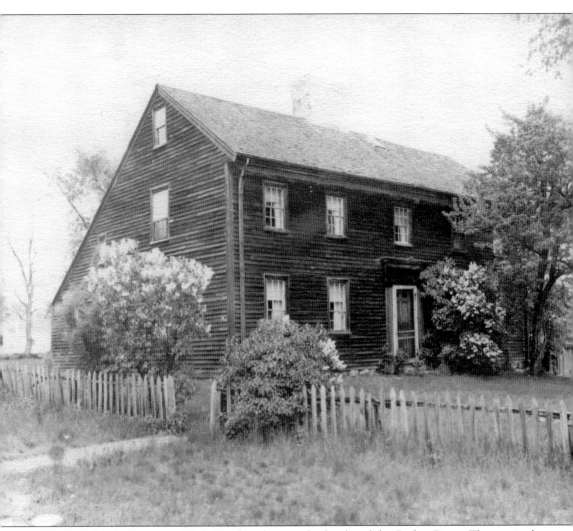

The Dole-Little House on High Road is close to the banks of the Parker River. The original house was built around 1715 for Richard Dole, a cattleman, with materials salvaged from a c. 1670 structure. It was a two-room, central-chimney construction with a small kitchen shed at the rear. The house underwent extensive restoration and rehabilitation in 1954, when it was owned by Florence Evans Bushee. It is now a property of Historic New England.

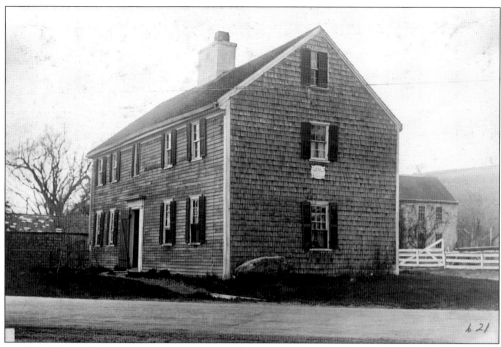

In 1727, Samuel Seddon was given land at the northwest corner of the Lower Green to construct "a tavern to be used for the refreshment of man and beast going to Parker River" (*Old Seaport Towns of New England* by Hildegarde Hawthorne, 1916). The tavern also served as the point of contact for the ferry service over the Parker River. A series of fires and a slight relocation in 1933 altered the appearance of the tavern, which has since been restored to a classic early-18th-century appearance. It was photographed by George Noyes.

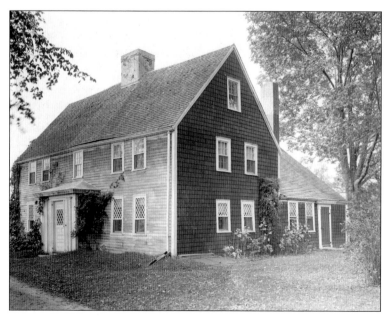

Highfields House, a First Period (1620–1720) structure built between 1705 and 1707, was home to Abraham Adams and his wife, Anne Longfellow, a granddaughter of Judge Samuel Sewall, who played a prominent role in the Salem witch trials. The house gets its name from the high fields, hay fields, and pastures surrounding the home.

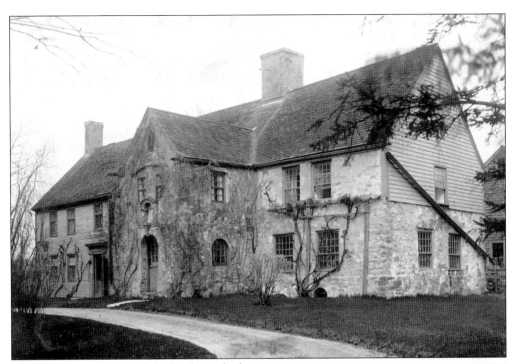

John Spencer was granted the land on which this house stands in 1635. The brick-and-stone manor house was built around 1690 by Daniel Pierce, a farmer, blacksmith, and malt maker. Home to the Little family for many years beginning in 1851, it is now a property of Historic New England and a national historic landmark, pictured here by George Noyes. The house, known as the Spencer-Pierce-Little Farm, is surrounded by over 200 acres of open land. At right is the stair hall of the manor house. When merchant Nathaniel Tracy purchased the home in the late 18th century from the Pierce family, he made changes reflective of the Georgian period.

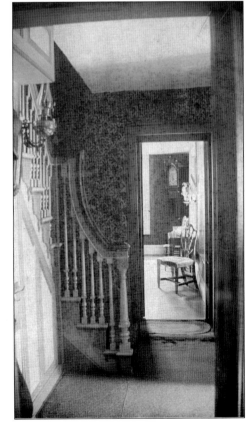

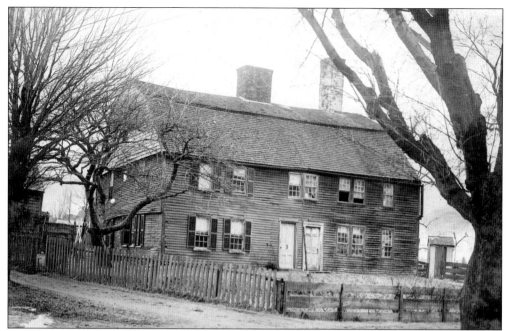

The Dr. Peter Toppan House is a grand gambrel-roofed structure built about 1697 by Toppan for his family. It is a fine example of Newbury's first period architecture. He was Old Town's first physician. Toppan (1634–1707) was three years old when his parents arrived in Newbury. It has been recorded that his death occurred as the result of a fall from Beniah Titcomb's wharf. The house was altered to a duplex in the 1800s and was restored to a single-family home in the mid-20th century. George Noyes took this photograph.

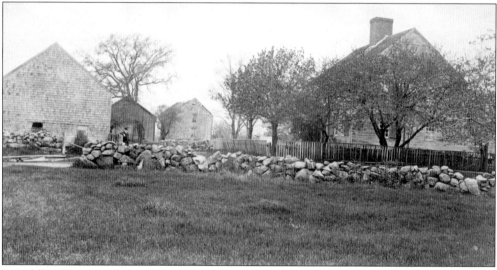

Longfellow Farm, on Orchard Street, was the ancestral home of the Longfellow family. William Longfellow married Anne Sewall in 1676, when this house was built on land given to the new couple by Anne's father. Their son Lt. Stephen Longfellow was the Byfield blacksmith and served as the inspiration for Henry Wadsworth Longfellow's poem "The Village Blacksmith." Anne Longfellow, who married Abraham Adams, was the daughter of William Longfellow and Anne Sewall.

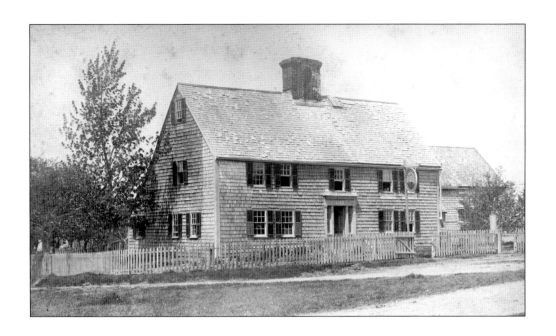

Eight generations of the Poor family made their home in this house, built about 1640 on Newbury Neck. The house originally consisted of one square room on the ground floor and a chamber above it. It was built by John Poor, who lived here until 1684, when he froze to death in the forest. Subsequent generations expanded the house. Capt. Jonathan Poor kept a tavern here until 1806, when the opening of the Boston and Newburyport Turnpike diverted travel to the new route. The old house was taken down in 1890.

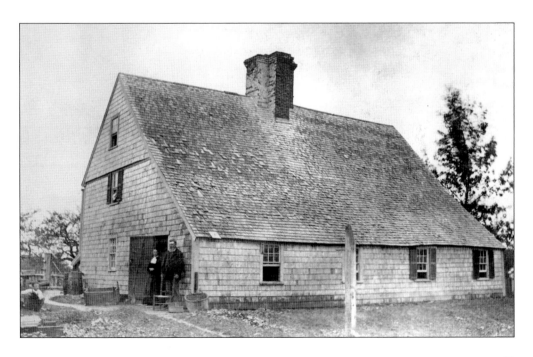

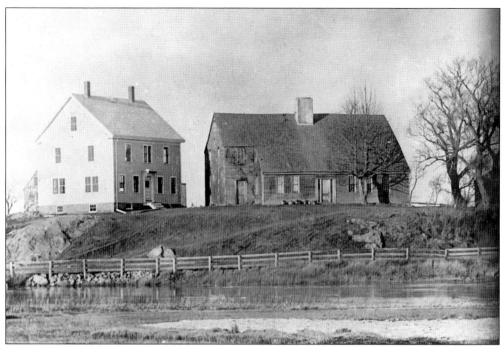

The original Leigh house (above, right) was built about 1700 and near the junction of Hay Street and Newman Road. The original house no longer stands. It was replaced by a handsome Colonial-style structure in 1895 (above, left). Below, family and friends celebrate the completion of the new house, docking their boats on the banks of the Little River.

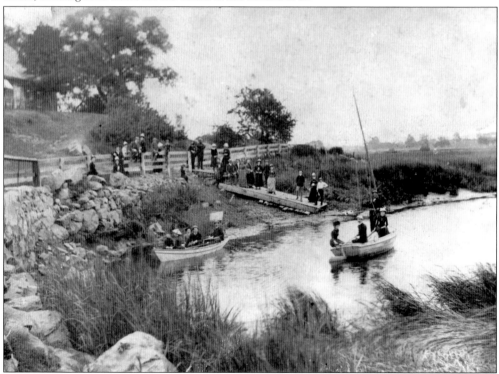

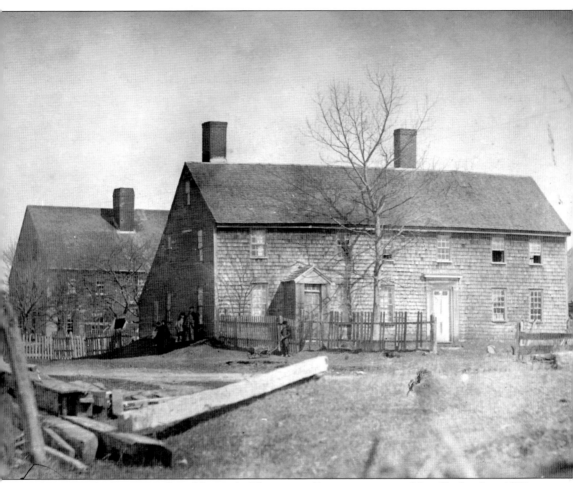

Thomas Hale (1606–1682) and his wife, Thomasine Dowsett, came to New England in 1637 during the Great Migration. In 1652, Hale acquired this fine house, built about 1650, from Stephen Kent in exchange for a farm in Haverhill. The Hale Homestead, as it became known, was deeded with a barn and 70 acres of marsh and upland on what is now known as Newbury Neck. Around 1656, Hale moved to Salem, where he was listed as a glover. In 1660, he sold the Newbury house and lands to his son Thomas. The following year, the elder Hale returned to Newbury and spent the remainder of his life living with his son in the family homestead. The house was destroyed by fire in 1923.

This garrison-style house on Kent's Island was built in 1651 by Richard Kent. In 1654, he sold it to Launcelot Granger and his wife, Joanna Adams, who made it their home for 20 years. Granger was born in Bedfordshire, England, about 1637 and came onboard ship as a cabin boy to Plymouth when he was about 14 years old. After a two-year apprenticeship to pay for his passage, he made his way to Newbury and settled on Kent's Island. The house was destroyed in 1884. This charming Colonial Revival drawing was done from a photograph.

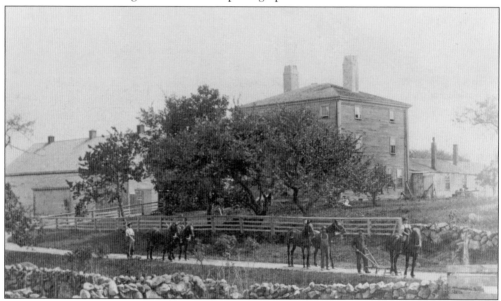

This Federal-period hipped-roof home was the centerpiece of a large farm on Kent's Island in the early part of the 19th century. It replaced the earlier house pictured above. The house burned in 1920 and was replaced by a more modest structure that John P. Marquand incorporated into the design of his new home in 1935, when he purchased the island.

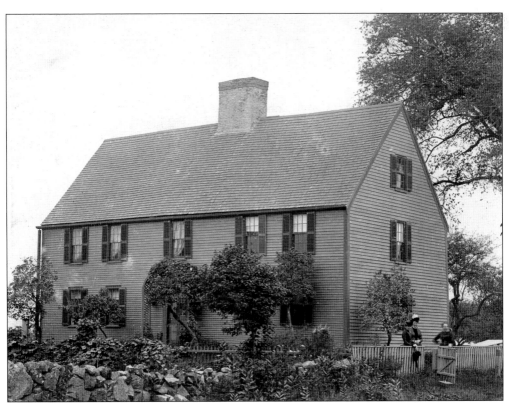

The James Noyes house on Parker Street was the home of the first pastor for Newbury. The Noyes family came from Wiltshire, England. The main block of the house was built in 1646 with additions in 1800 and again later in the 19th century. The house is listed in the National Register of Historic Places.

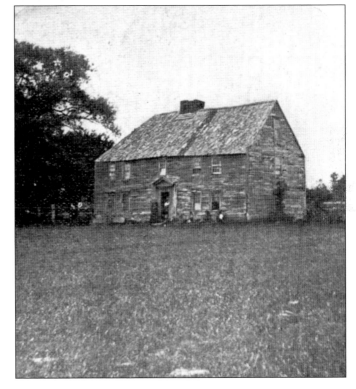

The Lull House in Byfield Parish was originally built as a garrison against the Indians about 1660. Late in 1692, a massacre occurred when Benjamin Goodrich, his wife, and two of his daughters were killed. A fire was set, but the house was not fully destroyed. It remained standing until the end of the 19th century.

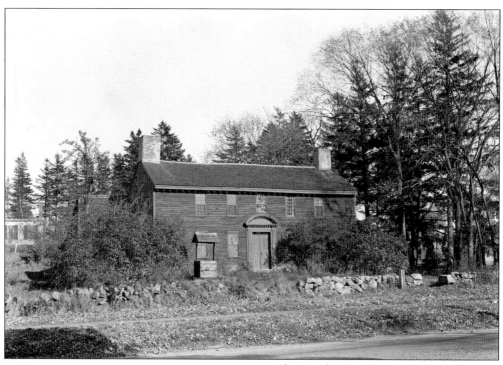

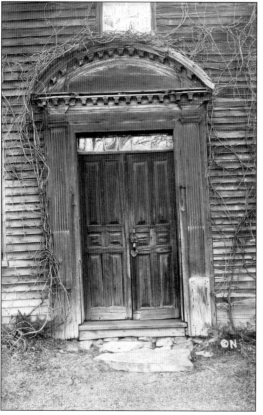

The Knight-Short House on High Road was built around 1715 by Nathaniel Knight. This handsome brick-end structure was once the home of blacksmith Nicholas Pettengill. Like the Toppan House, it was once a duplex and was later restored. Frank O. Branzetti photographed the house in 1940 (above). At left, the arched pediment doorway with Doric columns attracted the attention of curators from the Metropolitan Museum of Art, who acquired it for the American Wing. George Noyes was the photographer around 1920. (Above, courtesy of Library of Congress.)

Planted in 1713 by Richard Jacques, the Old Elm of Newbury stood for two centuries gracing the front lawn of the Jacques home on Parker Street. The tree is memorialized in a poem by Newburyport author Hannah Flagg Gould that recounts a love story between Jacques and his sweetheart. The two married, and generations of their descendants played beneath the elm. The tree was blown down during a storm in 1913.

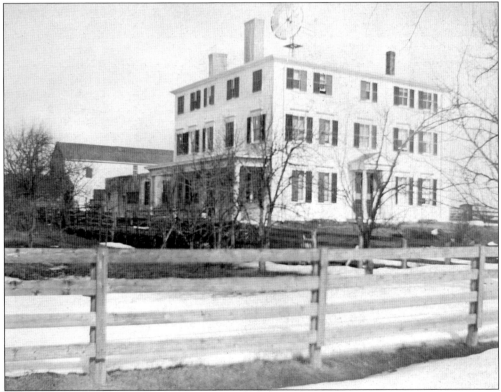

The Noyes-Tappan House on Little's Lane, a fine Federal-period building, was built by Revolutionary War privateer Offin Boardman for his son-in-law Amos Tappan. Tappan was born in 1775 and married Hannah Boardman in 1798. The house, razed by a private owner in 2012, is still mourned by local residents.

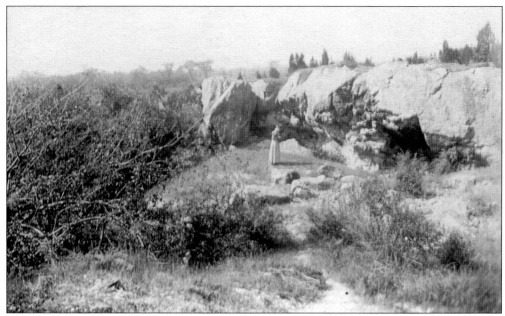

The glacial erratic known as the Devil's Den has been shrouded in mystery since the 1800s. The origin of the name is unknown but probably stems from the frenzy of the Salem witch trials in 1692. The Den was formed when Ens. James Noyes discovered limestone and opened a quarry in 1697. Limestone was a better source of mortar than the clam and oyster shells used previously. The quarry was closed with the discovery of higher-quality limestone in Maine. The Den continues to be of interest due to the presence of several types of minerals. Pictured above is Lizzie Ilsley, born in 1862. Located nearby are two rocks atop one another named Devil's Pulpit (below), the place where the devil was said to preach.

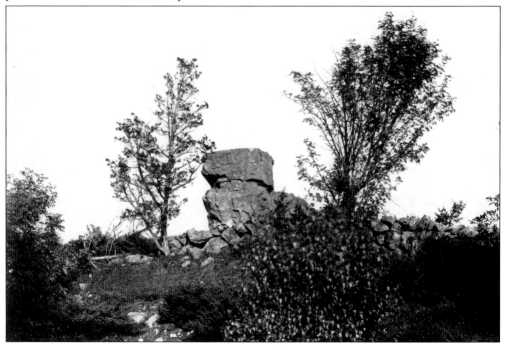

Near the Martin Burns Bridge over the Parker River, this wildlife management area consists of over 1,500 acres of second-growth forest, upland, and marsh. Popular with hunters and highly regarded by birders, it is maintained by the Essex County Sportsman's Association.

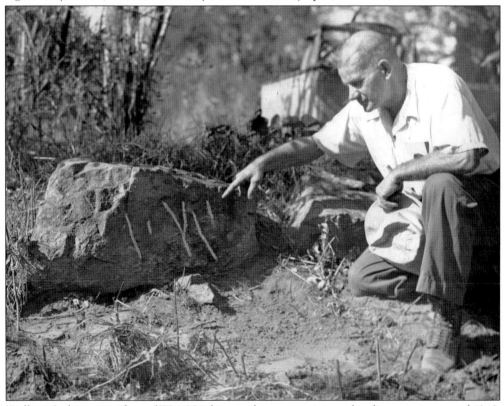

Wallace Ordway, a resident of West Newbury, is shown examining a local rune stone around 1940. There is a claim that Vikings came up the Parker River and established a landing site. Ordway was an avid local historian often called upon to identify ancient mysteries.

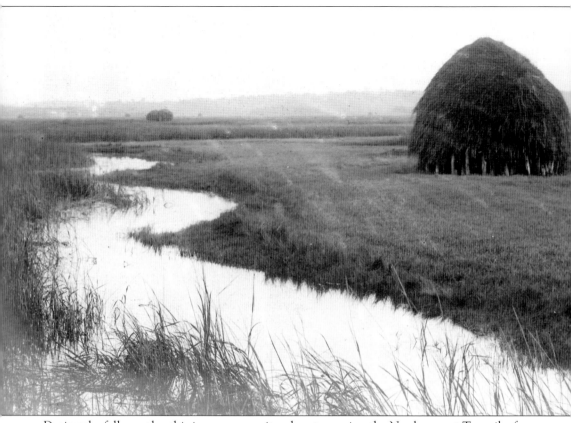

During the fall months, this is a common site when traversing the Newburyport Turnpike from Boston. The Great Marsh stretches for miles and is interrupted only by the great mounds of harvested salt hay. Although not as widely used as in times past, there are still local farmers who harvest the hay.

Milestone 33 on Middle Road is one of five milestones in Newbury. It is one of the oldest surviving milestones in New England and the third to be erected in Massachusetts. Milestones became a familiar site along the Bay Road from Boston to Portsmouth during the 18th century. "N 5" indicates five miles to the center of Newbury and "B 33" 33 miles to the center of Boston. There is also the date 1708 and a triangle design. The milestone was carved by gravestone carver John Hartshorn.

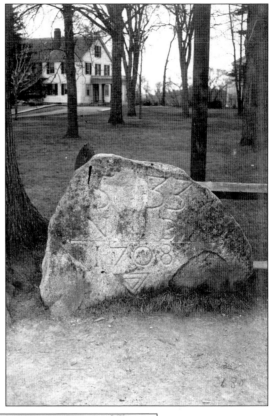

This view of Old Town Hill from the Parker River harkens back to Newbury's early settlement, when the community took root around the base of this local landmark. Here, stone walls denote property lines, and cows graze at the hill's summit, strikingly outlined on the horizon.

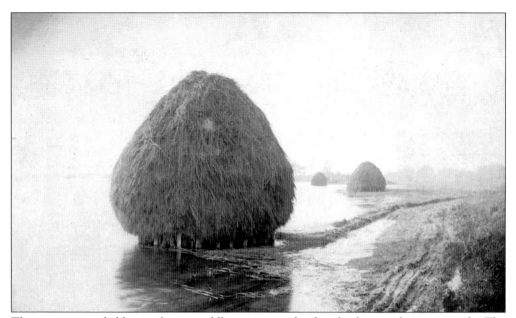

These great rounded haystacks on staddles are iconic landmarks dotting the countryside. The Great Marsh is the largest continuous stretch of salt marsh in New England, with over 20,000 acres of marsh, barrier beach, tidal river, estuary, and upland islands. Twenty percent of the Great Marsh is located in Newbury.

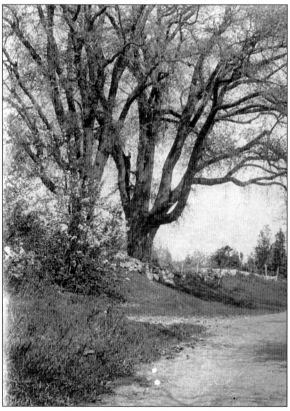

These massive and mighty elms along Newman Road in Old Town provided lush shade for those traveling this byway between the Bay Road and Hay Street. Sadly, they succumbed to Dutch elm disease.

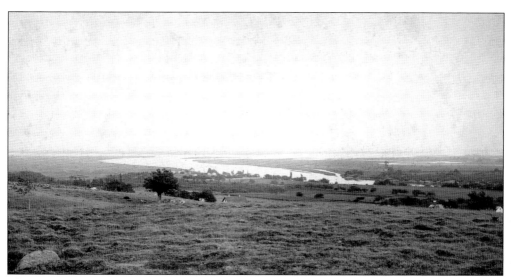

This sweeping scene from the top of Old Town Hill shows the dramatic change in topography from the uplands to the flatlands of the Great Marsh, with the dunes of Plum Island in the distance.

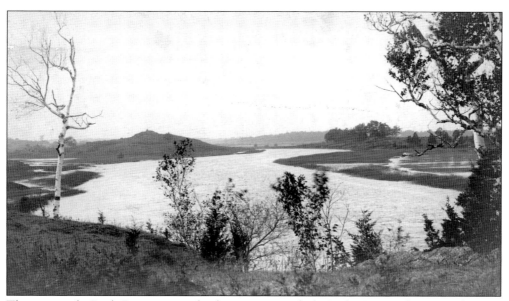

The area on the Little River just north of its junction with the Parker River is known as the Gut. Traditionally a swimming hole, the Gut boasts large rocks on the river's shore.

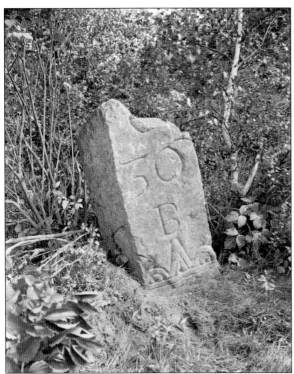

The 18th-century Milestone 36 is on the Boston Road in the vicinity of Four Rock. The top section of this milestone has been broken off. There is a bold geometric design at the base of the rock. It is believed to have been commissioned by John Dummer. The "36" indicates the distance of 36 miles to Boston. (Courtesy of Library of Congress.)

Moody's Pond is near the junction of Hay and Low Streets. This area has long been home to farms, some of which have remained into the 21st century, including Tendercrop Farm, formerly the Knight Farm, and the Silverledge Farm.

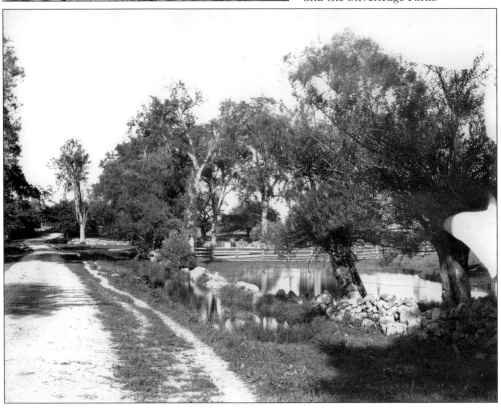

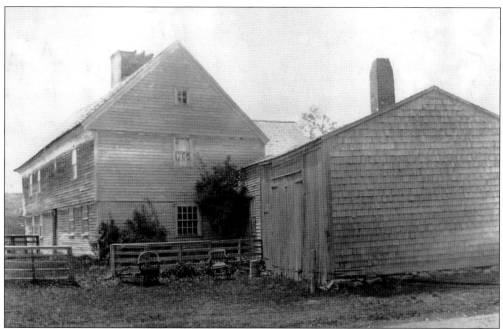

Edward Rawson arrived in Newbury in the late 1630s and made his home at this site, currently 267 High Street in Newburyport. At that time, this property was located in Newbury. Rawson was a wealthy and influential early Newbury settler who held a number of local political offices before becoming the first secretary of the Massachusetts Bay Colony in 1651. At this time, he sold his Newbury home to William Pillsbury, whose son Job built the house pictured here in 1700. The original Rawson house was dismantled shortly thereafter. The Pillsbury family lived here for over 200 years except for a few years during the War of 1812. At that time, the property was rented to David Emery, who operated a tavern on the site and was known for dealing in smuggled goods. In 1889, the building was burned by arsonists, and it was rebuilt to the original specifications in 1891.

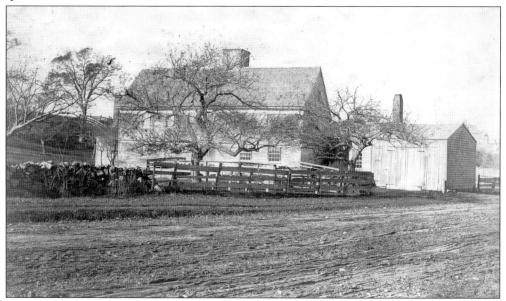

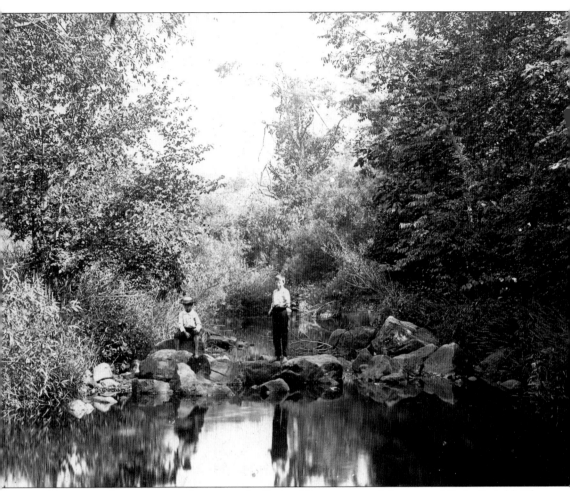

Two young boys are seen playing on the Parker River at one of the many falls in Byfield. The river meanders from the eastern shore of Plum Island several miles inland through marshes and wooded areas.

Three

CHURCHES AND SCHOOLS

Old Town Meeting House was constructed in 1635 near the Lower Green. In 1647, a new meetinghouse was built just beyond the Upper Green within the First Parish Burying Ground. A third and larger structure was completed adjacent to the second in 1661. The structure pictured here was the fourth to serve the First Parish and was built in 1699. After serving the community for over a century, it was replaced in 1806 with a larger, more refined building across the High Road.

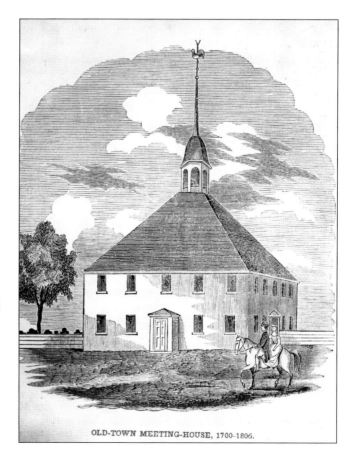

OLD-TOWN MEETING-HOUSE, 1700–1806.

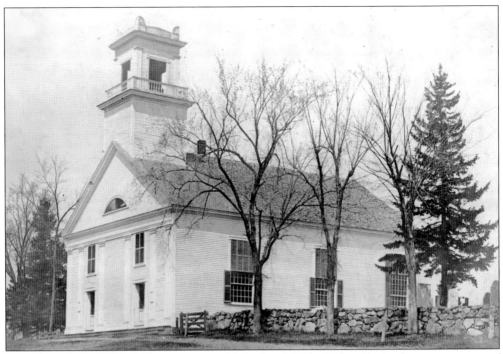

Byfield Parish, on Jackman Street, was established in 1702 by 19 families in the western parts of Rowley and Newbury. This church is the third on the site, the previous one having burned in 1833. This Greek Revival structure was destroyed by fire also after being struck by lightning in 1930. It was replaced with a brick building in 1932 that is now a private residence. George Noyes took this photograph.

The first minister of Byfield Parish was the Reverend Moses Hale, who served from 1702 until his death in 1744. He was installed in the newly built parsonage in 1704. This structure also became the home of Hale's successor, the Reverend Moses Parsons. The photograph is by George Noyes.

The Reverend Moses Parsons (1716–1783) served as the minister of Byfield Parish from 1744 until his death. In addition to his pastoral responsibilities, he was instrumental in founding Governor Dummer Academy. This image is an 18th-century silhouette.

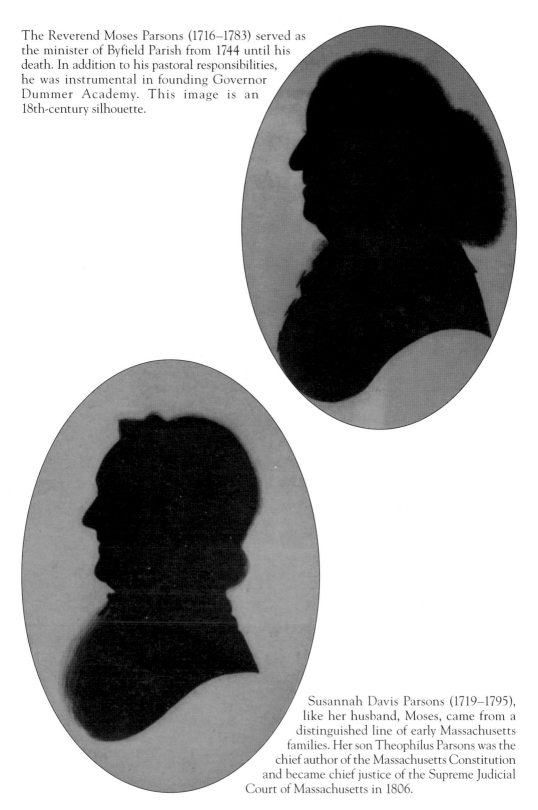

Susannah Davis Parsons (1719–1795), like her husband, Moses, came from a distinguished line of early Massachusetts families. Her son Theophilus Parsons was the chief author of the Massachusetts Constitution and became chief justice of the Supreme Judicial Court of Massachusetts in 1806.

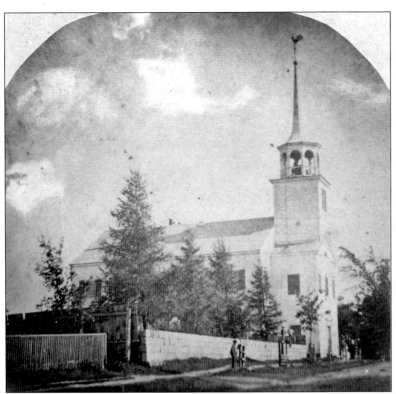

The First Parish Church has occupied six different buildings on three different sites during its nearly 400-year history. The building above is the parish's fifth, built in 1806 on the east side of High Road near the Upper Green. This photograph dates to around 1850; this building was destroyed by fire on January 26, 1868. Parishioners quickly raised funds to rebuild the church, which was erected on the opposite side of High Road and dedicated in March 1869. This building is pictured at right around 1930 and still stands today.

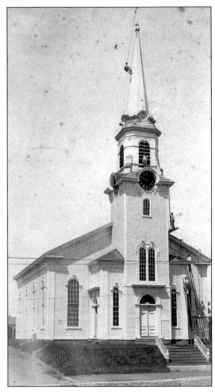

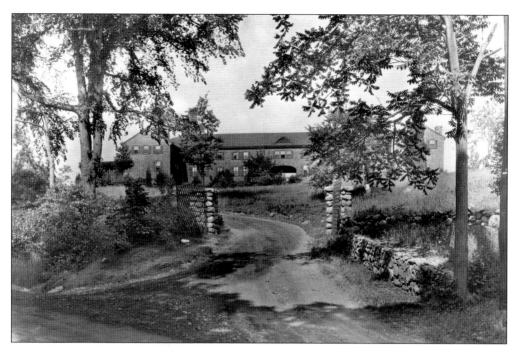

The Society of the Companions of the Holy Cross was organized in 1884 by Emily Morgan in honor of her invalid friend Adelyn Howard. In 1915, the Companions designed a large, three-story, shingle-style retreat house to provide a place for reflection and renewal. They named the place Adelynrood, combining Howard's first name with the word *rood*, which means "cross." Located on 15 acres on Elm Street in South Byfield, the retreat center is surrounded by gardens, pine forests, and meadowland. Below, the Common Room at the Adelynrood Center is one of several where guests may gather. There is also a large library and extensive gardens. This postcard is from around 1920.

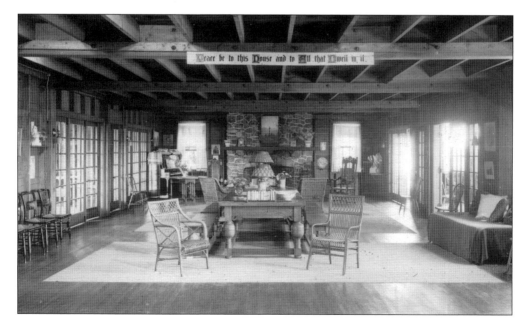

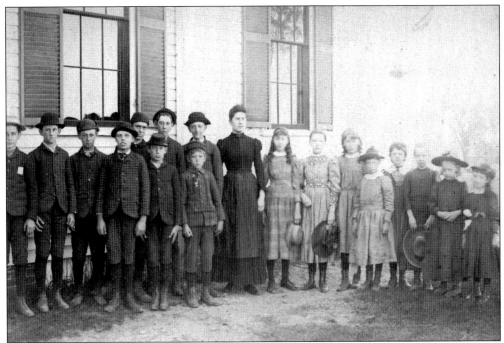

The schoolhouse on the Lower Green was built in 1877 to replace an earlier structure. It was in continuous operation until 1897, when the students were transferred to the new Woodbridge School. Today, the building is maintained by the Newbury Historical Commission and is open on summer weekends. Above, 17 students and their teacher pose in front of the schoolhouse in a late-19th-century photograph. From left to right are (first row) Everett Ilsley, Burke Thornton, J.N.C. Leigh, George Plumer, Harry Leiber, and Enoch Plumer; (second row) Henry Stevens, Stephen Plumer, Dan Dole, Miss Abott (teacher), Lottie Smith, Margaret Ilsley, Agnes Plumer, Elizabeth Churchill, Lena Thornton, Anna Leigh, Emma Leigh, and Mabel Plumer. Below, two unidentified children relax on the Lower Green with the schoolhouse beyond.

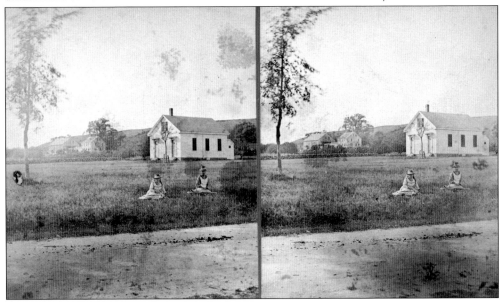

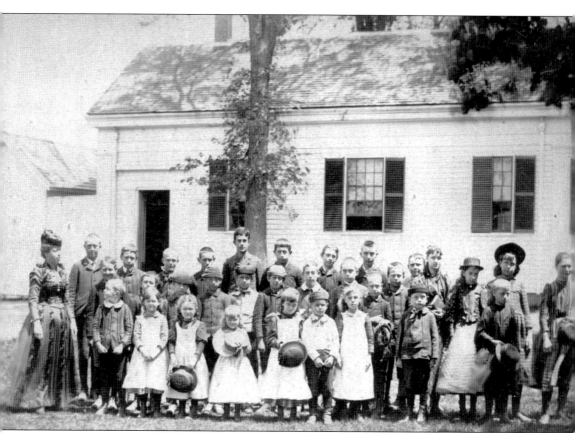

Students of Newbury attended this school on the Upper Green during the 19th century. This original two-room building was on the site of the home of the first schoolmaster, John Woodbridge, who was called in 1731 at an annual salary of 45 pounds sterling. When the Woodbridge School was completed, students from the Old Town District schools entered the new, larger school. From left to right are (first row) John Little, Feroline Woods, Alice Little, Edith Woods, Eliza Woods, Fairfield Winder, Lil Bohannon, and Mabel Little; (second row) ? Lunt, Irving C. Little, ? Lunt, Arnold Young, Arthur Jaques, Leonard Jaques, Gertrude Little, Sarah Little, Mabel Knight, and Marcia Little; (third row) Harry Jaques, Arthur Little, George C. Little, Xenophon Adams, Ellis Lunt, Mike Quill, and Howard A. Noyes.

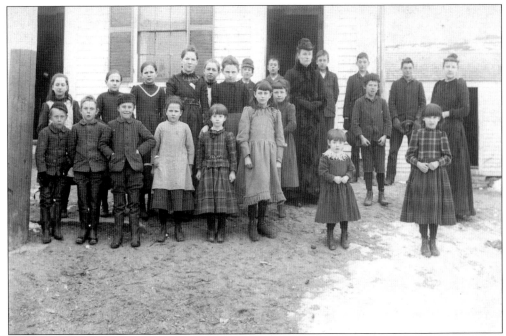

The schoolhouse on Middle Road was located in what was considered the farm district of town. It was near the cider mill run by Newell and Raymond Adams. The school mistress is elegantly garbed in a fur-trimmed coat.

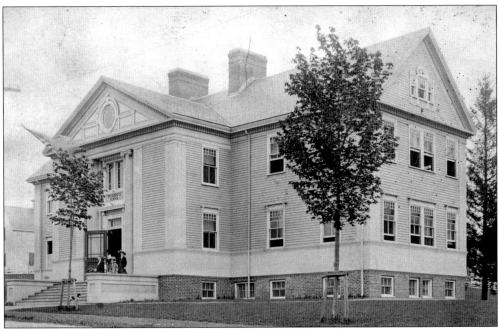

The Woodbridge School was built in 1898 and enlarged in 1908. This is one of Newbury's great examples of Colonial Revival architecture. The school was named after Newbury's first teacher and was established on the site of his former home on the Upper Green. The Woodbridge School was closed in 1996, and the building has been renovated for condominiums.

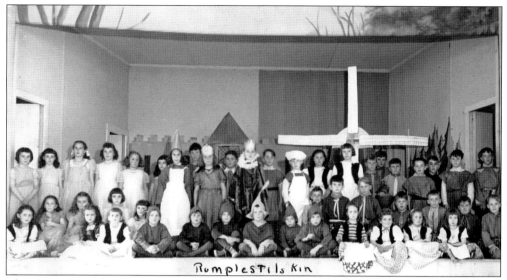

The classic fairytale "Rumplestiltskin," collected by the brothers Grimm for their *Children's and Household Tales* in 1812, was performed by all the students of the Byfield School in 1948. The operetta was directed by teacher Doris Currier.

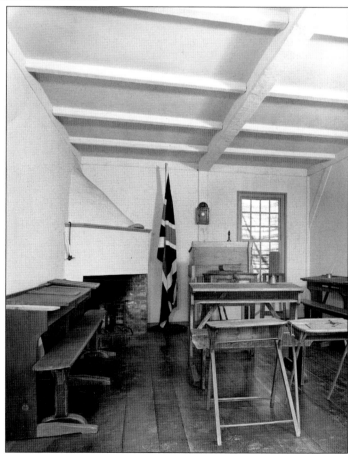

The original red schoolhouse opened its doors to students of Governor Dummer Academy in 1763 under the direction of master Samuel Moody. The building was reconstructed in 1938 by architect William Graves Perry, who was also the architect for Colonial Williamsburg in Virginia. The schoolhouse stands as a legacy to the rich history and traditions of the Governor's Academy and today is a small museum.

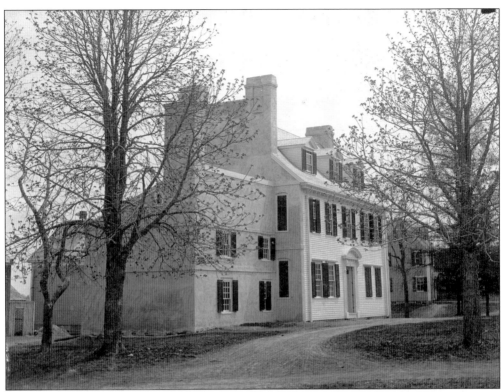

The Governor's Academy was founded in accordance with the will of William Dummer, governor of the Massachusetts Colony in the 1720s. The academy is in South Byfield on part of a 3,000-acre farm that belonged to Richard Dummer in 1632. The Dummer mansion, now the headmaster's house, is the oldest building on the campus. It was built between 1712 and 1715 as a summer residence for William and Catherine Dummer. When the academy first opened, both the master and the boarding students resided here. Below, the red schoolhouse, pictured around 1900, is adjacent to the Dummer Farm on Middle Road. In the early 20th century, the farmhouse was used as a boys' dormitory. (Below, courtesy of the Governor's Academy.)

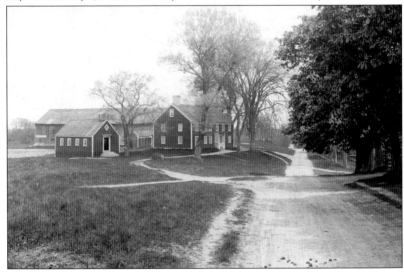

Four

BYFIELD

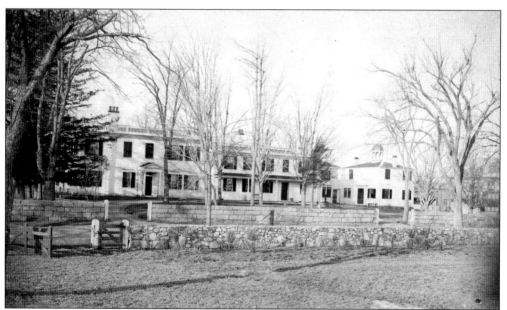

Fatherland Farm, a gentleman's farm, formerly on Central Street, was the home of Eben Parsons. Parsons (1748–1819) attended Governor Dummer Academy. When he left home to seek his fortune, he vowed that when he made "enough money" he would return home to buy the Dummer farm. After amassing a fortune as one of the largest importers in the country, he retired in 1801 and bought the farm, consisting of 150 acres. In 1802, he built the mansion house and named the property Fatherland Farm in honor of his father. The house burned in 1976, and a housing development is now located on the site.

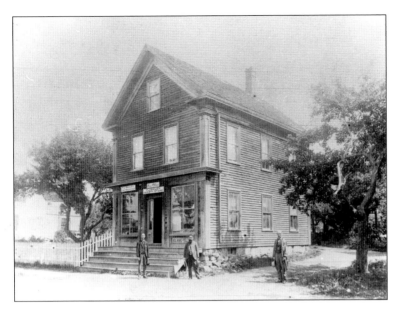

F.J. Bailey's variety store in Byfield Center was a hub of the community. Over the years, it housed numerous businesses, including the post office, a bakery, and a fish market. The locals came here to purchase their cigars. The Ladies Aid Society had rooms on the second floor.

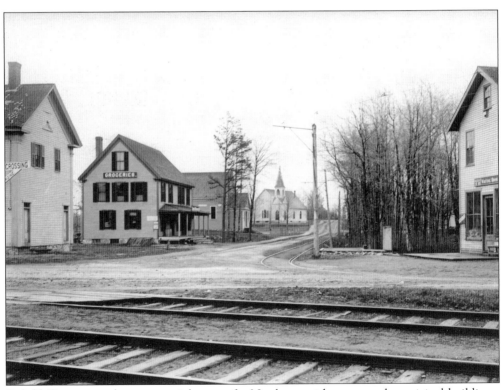

Byfield Center was the commercial center for Newbury, with stores and municipal buildings. Today, it remains a civic center for Newbury. This c. 1898 view shows Pearson's general store on the right. On the left is Gospel Hall, the grocery store (no longer standing), the Byfield Town Hall, and the Methodist church in the distance. The church was established in 1832. It has now been repurposed as condominiums.

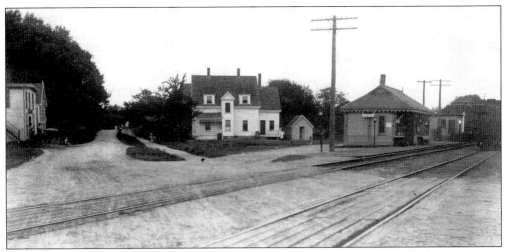

Byfield's train depot, pictured around 1900, was at the intersection of Central and Main Streets. The gray house was at one time Eva Jones's variety store. The train continued to run until December 1941.

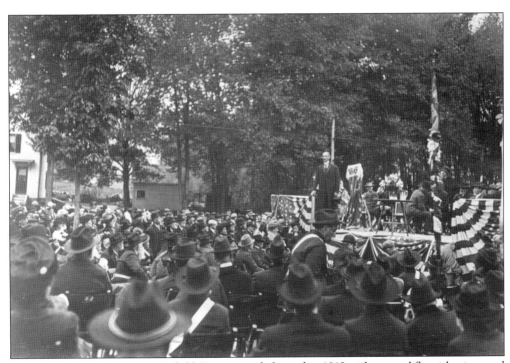

The Civil War Monument in Byfield Center was dedicated in 1912 with a grand flourish witnessed by townspeople and patriotic organizations such as the Grand Army of the Republic.

The Bailey house is on Church Street adjacent to Downfall Road, near the center of the village. Many of the houses in Byfield Center were built as mill workers' houses. This Greek Revival Cape-style house with connected barn, built around 1835, is a bit fancier.

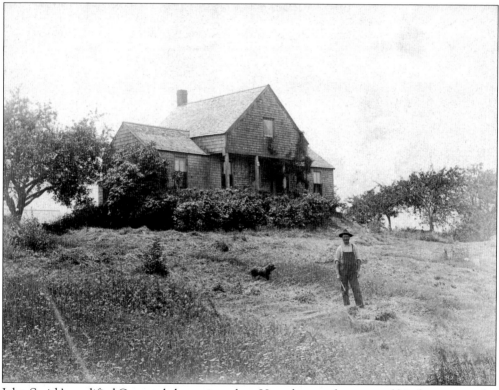

John Smith's modified Cape-style house is ageless. Here the proud owner and his dog pose on the front lawn. The "H" placard on the column of the front porch represents that this house received its ice delivery from Hicks.

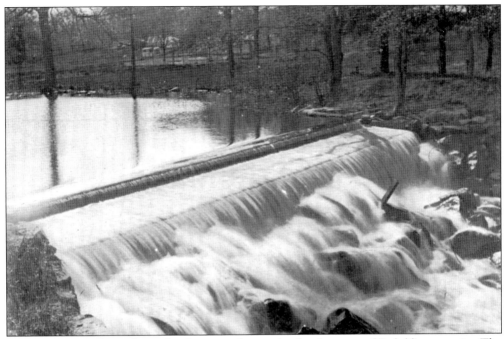

Central Street Falls on the Parker River was key to the development of Byfield's prosperity. The first water-powered mills were erected here in 1636. Both gristmills and sawmills were in operation on this site, as was eventually the Byfield Woolen Mill. Quascacunquen, the Native American name for this area, means "waterfall." Only the mill dam remains today.

The Byfield Woolen Mill was the first textile mill in Massachusetts, incorporated in 1794. The three-story mill building extended 100 feet, and the company was the village's largest employer. A fire damaged the operation in 1860. The mill was rebuilt, but a second fire in 1932 destroyed the building. Inventor Jacob Perkins of Newburyport also had a mill to cut and head nails here in the early 19th century.

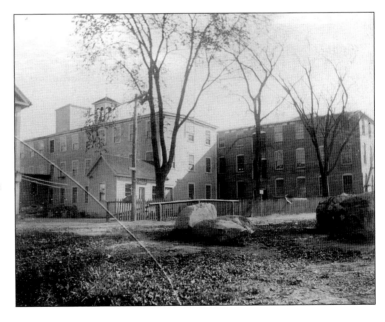

Benjamin Pearson purchased the land on which his family homestead was built in 1709. The rooflines and chimneys of the mill buildings can be seen to the right of the dwelling. The centuries-old Pearson elm was considered the largest in the commonwealth. It was blown down during a storm in 1898.

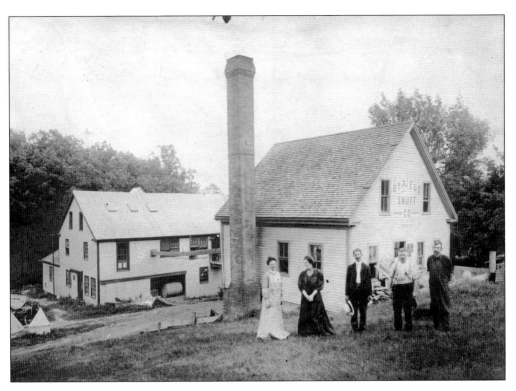

The Pearson family operated mills on their property from the 17th century onward. In the early 18th century, Benjamin Pearson purchased a gristmill and a fulling mill from the Cheney family. Pearson built his own mill about 1830 and converted it to snuff production by the 1860s. Ten generations of the Pearson family worked the mills, and it was the oldest and last water-powered snuff mill in the country when it closed in 1986. Below is the lower mill on the Parker River, which continued to be used as a sawmill. It was the oldest building in the mill complex.

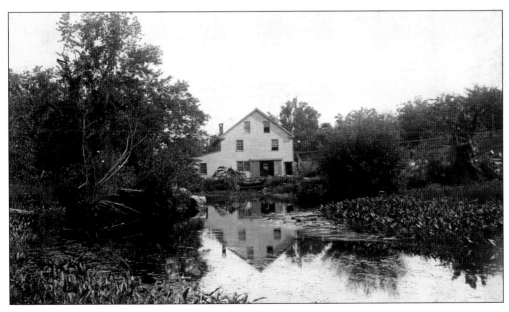

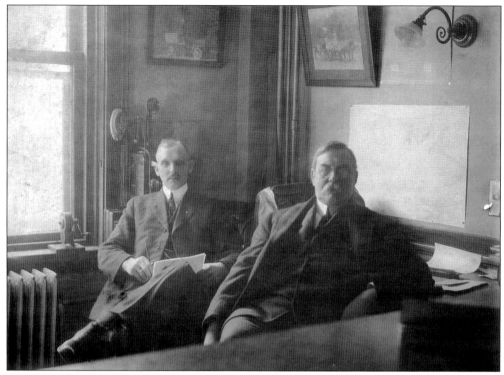

Charles Bailey (left) and Benjamin Pearson (right) confer in the main office at the Pearson Snuff Mill in the early 20th century. Note the telephone and pencil sharpener on the windowsill. The Bailey family had also purchased a major interest in the nearby Larkin and Morrill mill on Larkin Road.

Carl Pratt is pictured here at the power station for the electric trolley. The power station was built about 1899 on River Street in Byfield.

The Larkin and Morrill mill was originally owned by the Wheeler family. Over the course of 250 years, it was also owned by the Noyes, Tenney, Larkin, Morrill, and Pearson families. It was purchased by the Pearson Tobacco Company in 1899 and was later known as the Byfield Snuff Company. The wagon shown here in the late 19th century, carrying a cargo of snuff, still carries the banner of Larkin and Morrill.

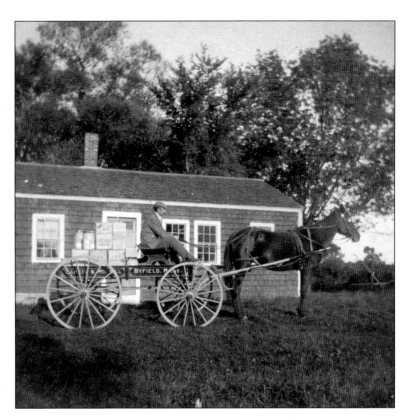

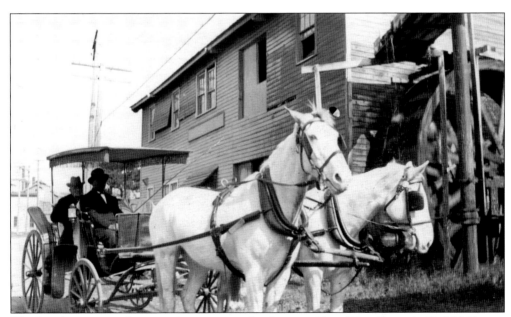

This handsome pair of carriage horses pauses by the sawmill on River Street in Byfield Center. This was one of several active mills in the community.

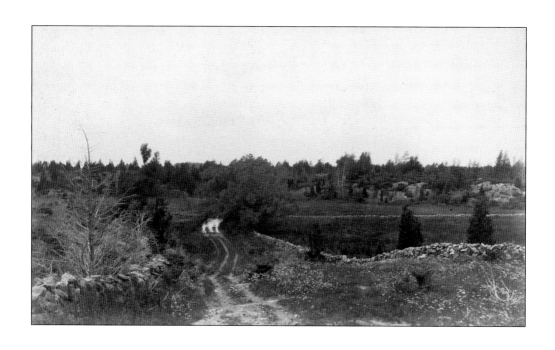

Downfall Road, a picturesque path with pastureland, giant boulders, and rambling stone walls, originally extended from Old Town to Byfield Center. Today, it dead-ends before Interstate 95. Once a wild terrain with glacial erratics, it is now a residential road on the Byfield end.

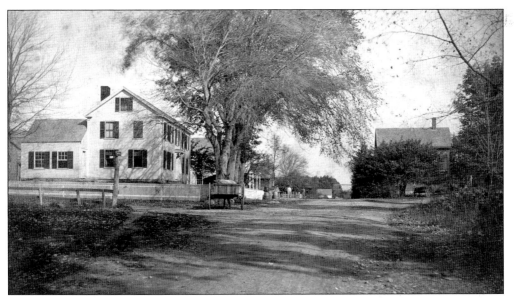

A c. 1898 rural gathering is held at the intersection of Main and Forest Streets. Forest Street is on the left, and Lunt Street is on the right. Byfield boasts many gracious Colonial residences, such as the one shown here on the left. Townsfolk gather to chat as their horses and wagons wait nearby.

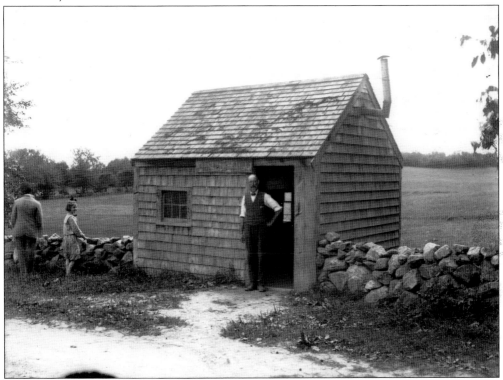

The village had a post office beginning in 1826, with Benjamin Colman serving as the first postmaster. South Byfield's rural post office was on Elm Street across from Adelynrood along the edge of Peggy's Pasture. Shown here in 1905 is Postmaster Frank Ambrose.

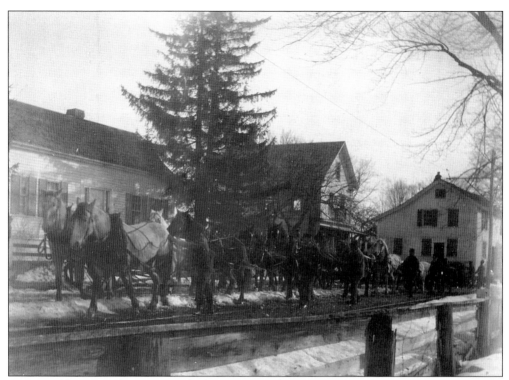

A team of horses and oxen is readied to move Paul Pearson's store down Main Street in the village. In New England, it was common to move buildings from one part of the town or village to another.

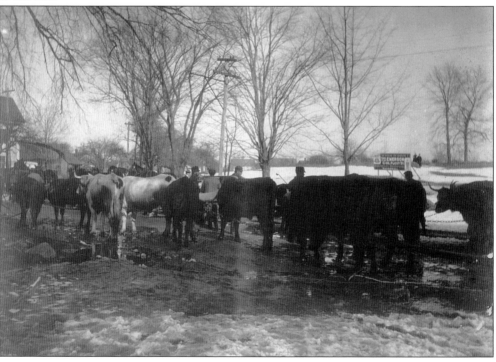

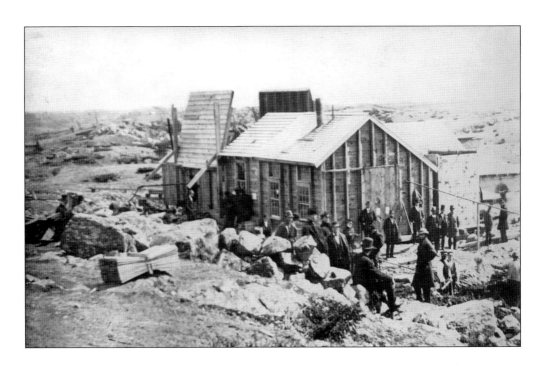

This view of the Chipman Silver Mine on Scotland Road shows the workers around 1875. The mine was in operation for a short time during the late 19th century but was not as successful as prospectors had hoped. Below, a group of potential investors has gathered at the minehead and office.

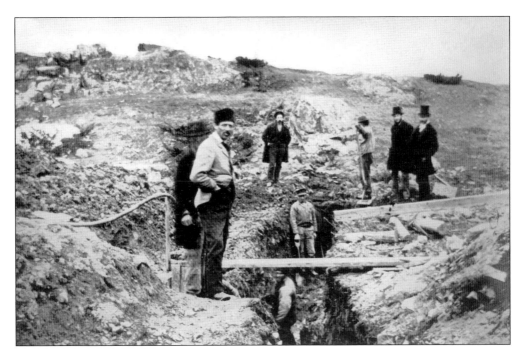

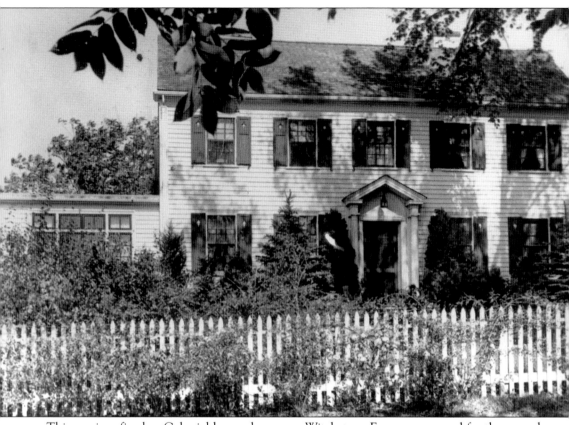

This gracious five-bay Colonial house, known as Witchstone Farm, was named for the carved stone located along the front of the property. Dating from the early 18th century, it may have been carved by the same man who carved the Newbury milestones.

Five

AGRICULTURE

Knight's Mill and Old Town Hill are pictured here. A mill was on this site from the 18th century onward. The first burned in 1803, and another was built in 1813. For many years, crops of onions and apples were stored in the old mill, and the railroad from Knight's Crossing would stop to collect the harvest for transport to Boston. Agriculture was the mainstay of Old Town for centuries. Farms lined the High Road and the area around Old Town Hill. Crops included many vegetables but especially onions. Considered the country's leading onion-growing area, it was not unusual for a farm to produce 40,000 pounds of onions annually.

Above, apple trees flourish in an orchard along Newman Road. The first apple tree was planted around 1712 at the Adams family farm on Orchard Street in Byfield. By 1854, an estimated 21,000 apple trees were under cultivation in Newbury. Thousands of apples were harvested and shipped to New York, Philadelphia, and even London. Below, one of many apple pickers rests to enjoy the fruits of his labor.

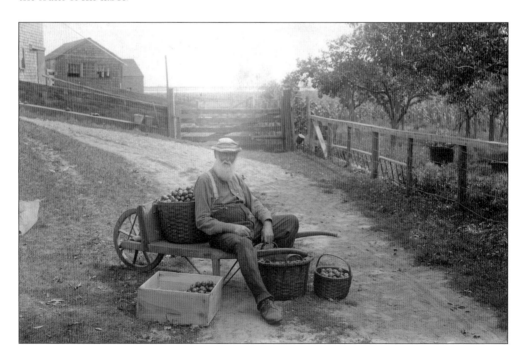

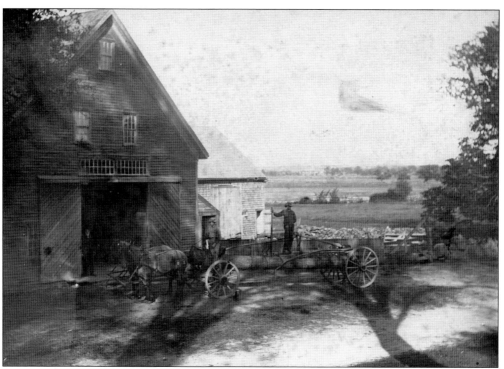

The Coffin Farm was one of Newbury's many small farms. William Coffin is seen standing on the wagon in front of his very fine barn.

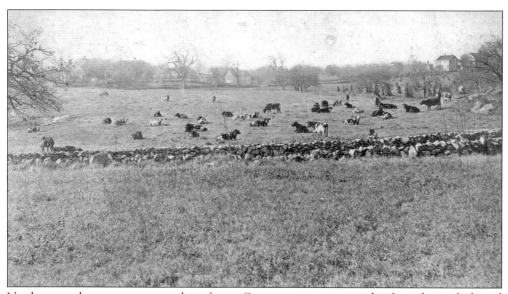

Newbury was home to numerous dairy farms. Cows were a common sight along the roadside and grazing in the pastures. Here the cows are enclosed in a large area surrounded by stone walls. The double stone enclosure in the foreground is most likely an animal pound.

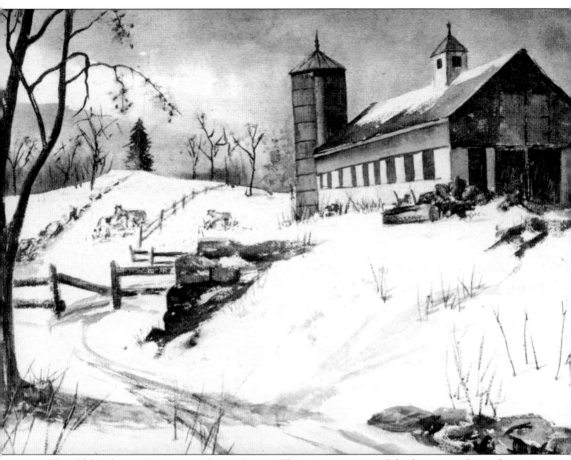

The Old Jackman Farm is on Green Street. This winter scene of the barn was drawn by artist Mildred G. Hartson (1904–1997). Hartson worked on the North Shore of Massachusetts and was a member of the Rockport School of artists. She worked in oils and watercolors and was also a printmaker.

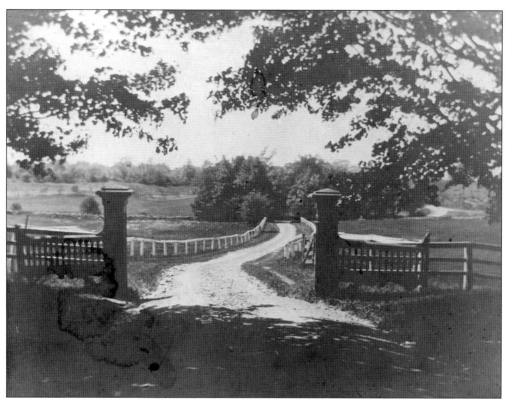

This bucolic early-20th-century view shows the lane leading to the Colman Farm at the corner of Colman Road and Elm Street. This was a dairy and market garden farm in operation until after World War II. (Courtesy of Elizabeth Armstrong.)

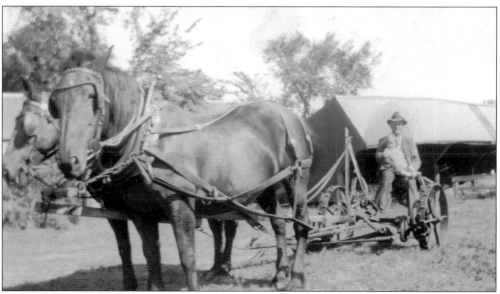

Horses Pic and Pat pull the mowing machine at the Colman Farm, driven by Joe Page. The photograph was taken in 1941. (Courtesy of Elizabeth Armstrong.)

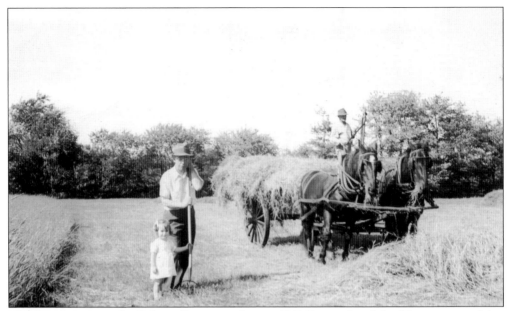

This haying scene at the Colman Farm was taken in 1941. Pictured are John Harrington with his daughter Elizabeth and the horses Pic and Pat. (Courtesy of Elizabeth Armstrong.)

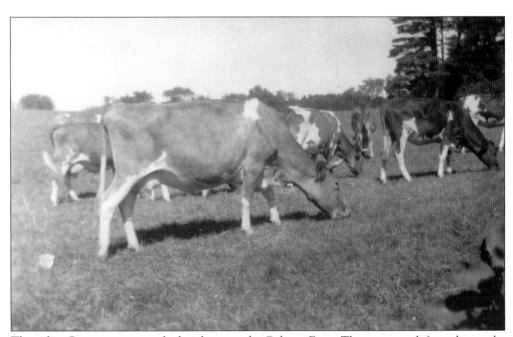

These fine Guernsey cows made their home at the Colman Farm. They were stock from the nearby Appleton Farm in Ipswich. Guernsey cows are known for their rich golden milk and cream.

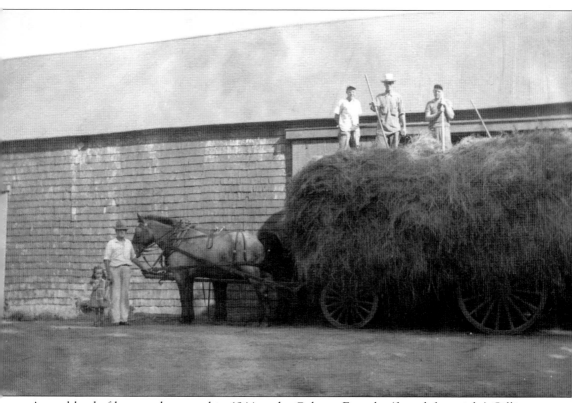

A good load of hay was harvested in 1944 at the Colman Farm by (from left to right) Gillie, Sam, and John atop the wagon pulled by Queenie and Smokey. Jim Cleigh and his great-niece Liz Harrington stand to the left. (Courtesy of Elizabeth Armstrong.)

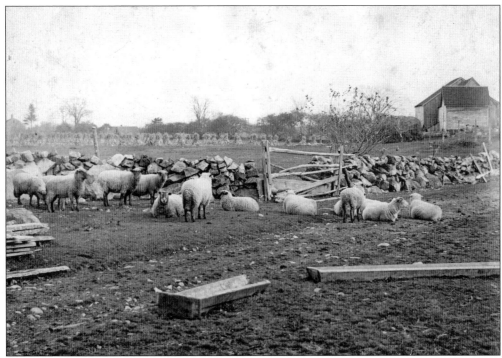

The Adams Farm on Middle Road has been worked by the same family for generations. Above, a flock of sheep is pictured on the farm in a c. 1880 photograph by Albert S. Dyer. Below, members of the Adams family harvest hay in July 1920. Newell Adams is seen atop the hay wagon in the foreground, while Raymond Adams is on the rear wagon. James K. Adams is at left on the ground. The farm was also well known for its cider mill. (Both, courtesy of Donald Quill.)

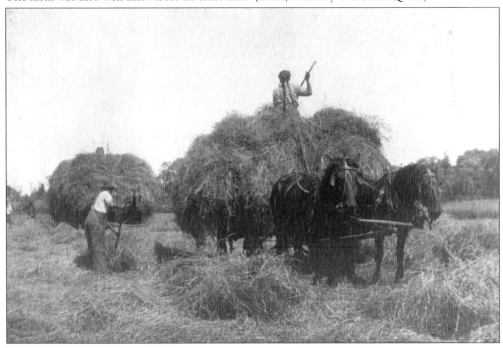

Six

OLD TOWN

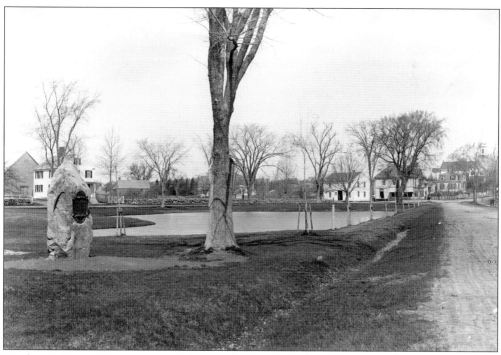

Newbury's Upper Green is part of the town's historic district. The original settlement in 1635 was south of here along the Parker River. The Upper Green, laid out in 1642, served as a militia training ground and became the new town center. The First Parish Church was built in 1646 and has been housed in several different structures. The current one, built in 1869, is visible near the top of the photograph. The monument commemorates the site of a military encampment during September 1775 under the command of Benedict Arnold.

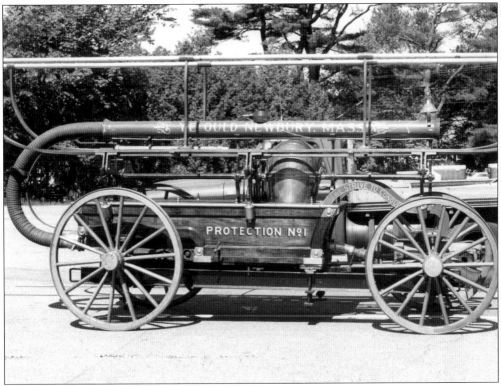

After mechanized firefighting equipment replaced hand-pumped wagons, these early machines found new life as the focal point of fireman's musters throughout New England. At these festivals, typically sponsored by veteran fireman's associations, teams would compete to spray the longest stream of water from their machines. The Ould Newbury Handtub Association was formed for this purpose in 1949. A 1951 souvenir program from the Old Town Jamboree and Fireman's Muster, sponsored by Protection Fire Company No. 2, holds that "fireman's musters are as traditional to New England as Plymouth Rock. They are an institution. Long live the musters."

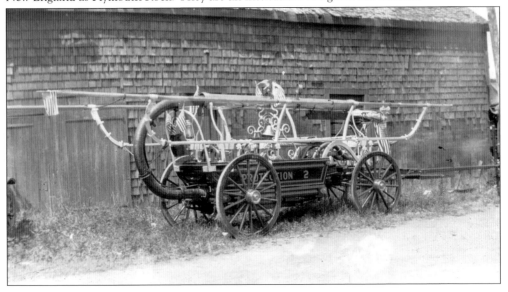

This icehouse was located at Quill's Pond on Hay Street in Old Town. In the c. 1880 view below, men are putting ice blocks onto the conveyor belt for storage in the icehouse. As refrigeration became available in the early 20th century, it brought the demise of local ice-harvesting businesses.

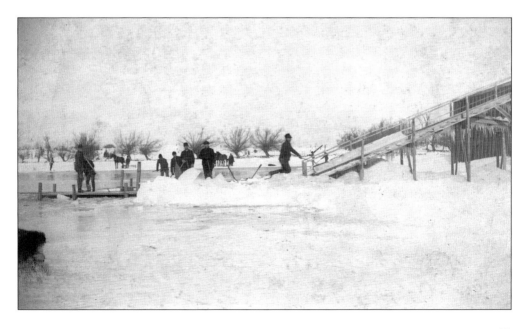

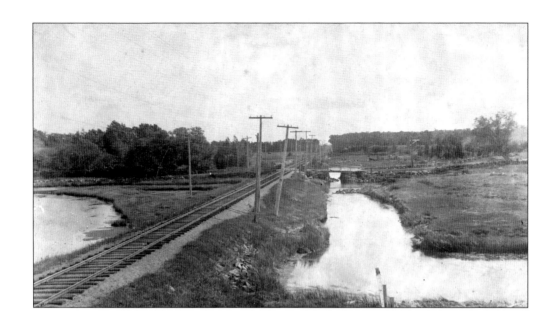

Four Rock Bridge was in use by 1663. Originally called the Mill Bridge, it crosses over the Little River on Boston Road. Below, the stereoview captures two gents lingering on the bridge while a third one has a swim in the river.

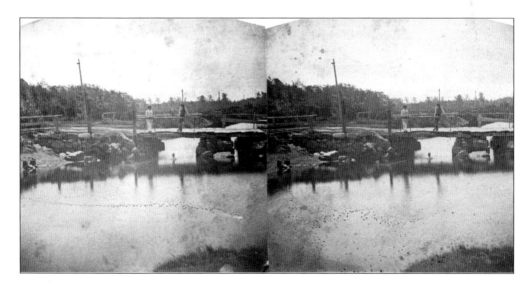

The Dole House is near Newbury's Lower Green. Though the area appears bleak in this winter photograph, the farms along the High Road were lush with crops during the growing season.

This c. 1910 photograph shows the Newbury Grange Hall, which was located across from Parker Street and served as a community meeting space and center of town activities for many years until it burned in 1927. The replacement for this building was sold to the town in 1937 to serve as the town hall. Notice the watering trough to the right. Grange halls were focal spots in New England communities. Originally founded as farming and social organizations, they offered educational programs and social events.

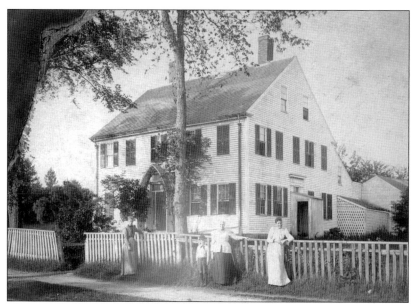

The Lunt family lived in this house at 21 High Road, near the Upper Green. Lorenza Etta Lunt (née Ross) is pictured at the far left. Lorenza married Charles A. Lunt, a carpenter, in 1873, and the couple had four children.

The tollhouse on the Newburyport Turnpike at the intersection of Middle Road was owned by Madeleine Dolliver. The Newburyport Turnpike was constructed in 1804, reducing the load carried by the Bay Road, now Route 1A. The turnpike opened in February 1805 as a straight and faster route from Boston to Newburyport.

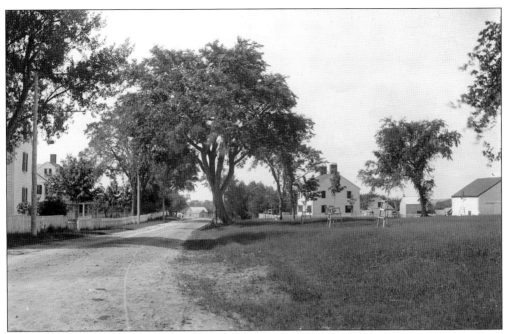

Early community life centered around Newbury's Lower Green, and the first meetinghouse was on or near this tract of land. Though the settlement moved its locus to the Upper Green in 1642, the Lower Green remained an open community space. In this early-20th-century photograph, new trees have been planted, perhaps to replace trees that had died or to beautify the public area.

Rustic bridges like this one were essential for transportation throughout Newbury's early history, as the area's marshlands and countryside are divided by numerous rivers and streams.

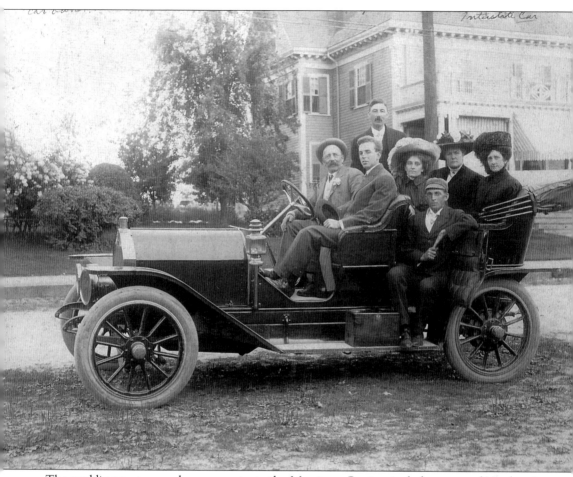

The wedding party seen here en route to the Merrimac Station includes many of Newbury's prominent citizens. Seated in the front seat are Benjamin Pearson, the car owner and driver, and Henry L. Bailey. Other members of the wedding party, listed on the photograph from left to right, include "George Seavey, A.M.B., 'Eddie', Mrs. Pearson, and Aunt Grace."

Seven

ALONG THE HIGH ROAD

Located at 30 High Road, the Sewall House was built before 1678 by Henry Sewall Jr., who first came to Newbury in 1635 and permanently settled here in 1661. Henry's eldest son, Samuel (1652–1730), became chief justice of the Massachusetts Superior Court of Judicature, now known as the Supreme Judicial Court of Massachusetts. Samuel was one of the justices in the Salem witch trials of 1692, a role he regretted later in life.

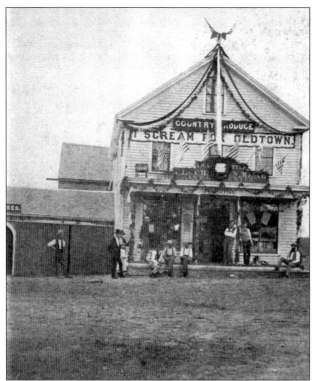

Little's Store was at the corner of the High Road and Parker Street, near the Upper Green in the section of Newbury known as Old Town. This building stood until 1885, when it was destroyed by fire. A new store was built on the same site. A typical general store, Little's sold grain, meal, flour, and groceries, served as the local post office, and had connected stables for horses.

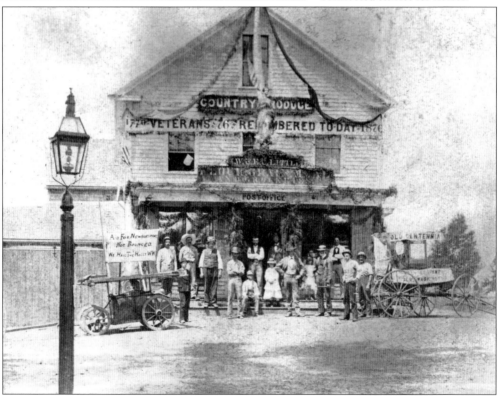

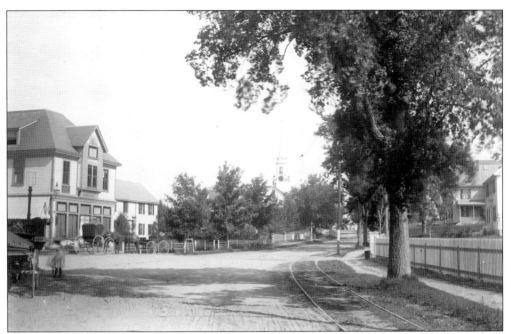

The large building at left housed Dole's Grocery, which replaced Little's Store after an 1885 fire. The steeple of the First Parish Church rises above the trees farther north on the High Road. This building was erected in 1868 after a fire destroyed the meetinghouse located across the High Road, which was the parish's fourth on that site.

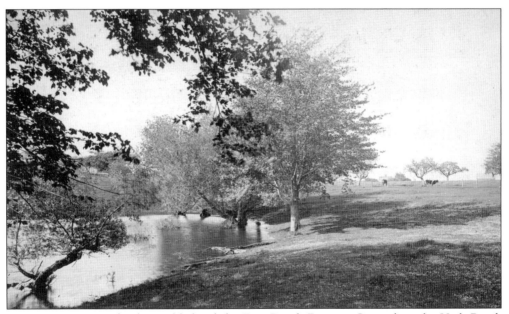

Meeting House Pond is located behind the First Parish Burying Ground on the High Road. At one time, the pond was tidal and included a "floating island" that rose and fell with the tides. However, 20th-century construction projects changed the pond's water supply, and the phenomenon ceased.

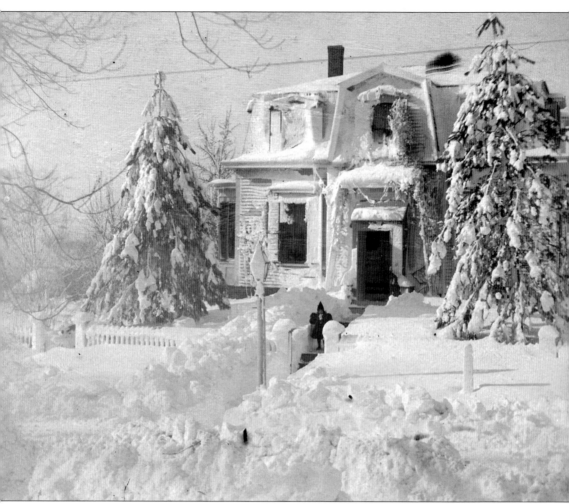

This c. 1870 home at 28 High Road is buried in snow after an 1898 storm. The year 1898 brought two particularly bad winter storms to Newbury, one in early February and one in late November. Both storms halted train service, closed schools, stopped communications, and damaged property, particularly on the waterfront. The February storm was proclaimed by the *Newburyport Daily News* to be the "most severe in the memory of the traditional oldest inhabitant." A February 1 edition of the newspaper observed that "nature was not content in sending our complement of snow on the installment plan but shipped it in one great bulk." The article goes on to describe the post-storm scene as "one of the wildest, most picturesque, and awe-inspiring gazed upon for years," a sentiment reflected by the snow-laden trees and bundled child in this photograph.

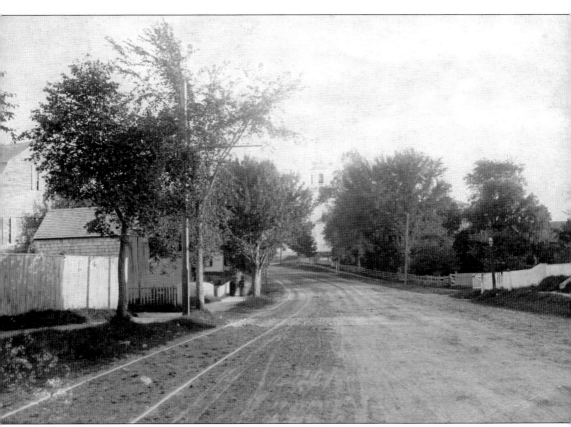

This view of the High Road north of the Upper Green includes trolley tracks on the left side. In the 1890s, electric rail service arrived in Newbury, replacing a previous horse-drawn rail system. The new electric cars required extensive infrastructure updates, including construction of a power station in Byfield, erection of a garage to store and service the cars, and installation of poles and wires along the entirety of the route. Train service was frequent and regular, as recalled decades later by Frank L. Witham of Byfield. According to a *Georgetown Weekly* article featuring Witham, "there was a car every hour at quarter of the hour from 5:45am until 9:45pm. The 9:45 evening car was the last car to Newburyport, Rowley, or Ipswich. The return trip from Newburyport to Haverhill left once an hour on the half hour to come to Governor Dummer Academy." With the introduction of the automobile, trolley service ceased in 1919.

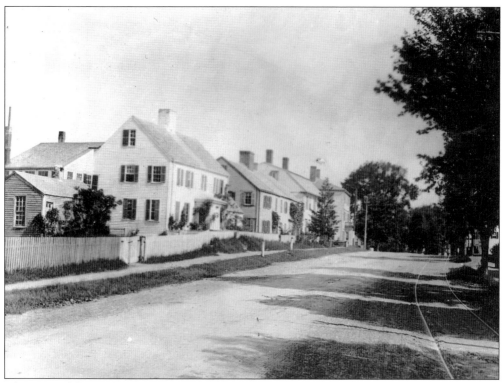

This view of the High Road north of the Upper Green includes the Plummer House in the left foreground. The oldest section of this house dates to 1711, and the northern portion was added in the mid-18th century. Further additions were made in the ensuing decades to give the house its sprawling footprint. The Swett-Ilsley House lies just beyond the Plummer House and predates it by 40 years.

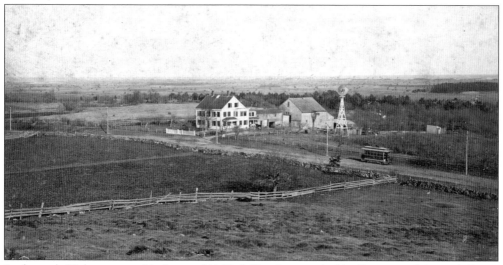

In the early 20th century, this farm at 211 High Road was owned by George and Amanda Lunt. At that time, Newbury was a largely agrarian community. Apples were a principal crop on many local farms, including the Lunts'. Newbury apples were shipped around the country and even to England.

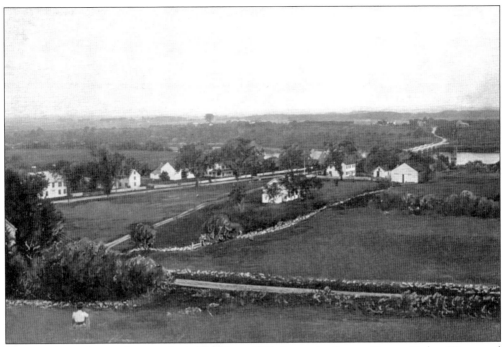

This south-southeasterly view from Old Town Hill shows the Lower Green, Parker River, and marshes beyond. The Parker River Bridge carries the High Road across the river, and Newman Road is seen in the foreground. The schoolhouse on the green was built in 1877 and remained in continuous operation until 1897. The school was then in use sporadically until 1909. This photograph has been hand painted.

Florence Evans Bushee was born to Florence Fowler and Wilmot Roby Evans in December 1881. Bushee was married twice, first to Wells Dibble and later to Rev. George A. Bushee. Throughout her life, Bushee was an active local philanthropist and preservationist.

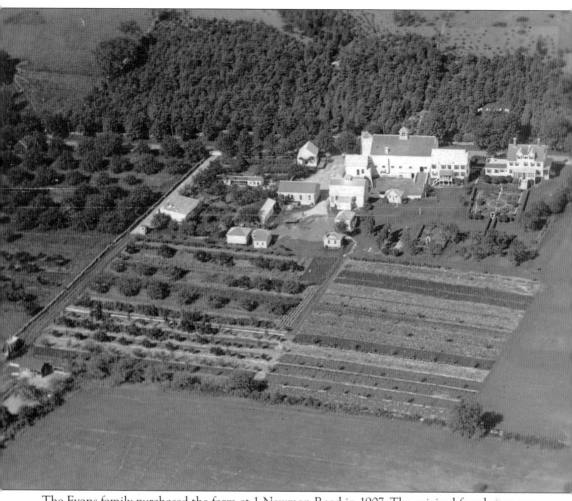

The Evans family purchased the farm at 1 Newman Road in 1907. The original farmhouse was built around 1800 by the Newman family. In 1925, Florence Evans Bushee inherited the property and ran it as Old Town Hill Farm. At its peak, the farm included the main house, a carriage house, separate horse and cow barns, a blacksmith shop, a heated garage, a potting shed, formal gardens, and orchards. A forward-thinking preservationist, Bushee worked with the Trustees of Reservations to create Old Town Hill Reservation, donating 126 acres of property near her farm in 1952 and adding more land in later years. Bushee was also active in historic preservation efforts, undertaking the restoration of several historic buildings including the Seddon Tavern, built in 1728, and the Dole-Little House, built in 1715. In a tragically ironic turn of events, Bushee's own estate was razed by developers in 2013.

Young Florence Evans had a penchant for horses and is seen here riding with a dignified grace that belies her age. As an adult, Bushee maintained a working farm and raised show horses at her Old Town Hill property. Her most celebrated horse was named Flowing Gold.

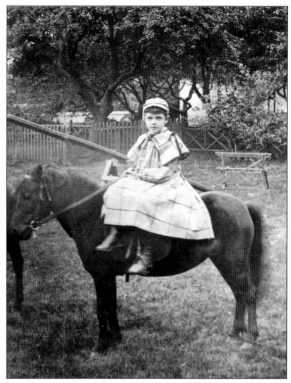

Florence Evans Bushee is pictured with John P. Marquand in her home at Old Town Hill Farm. Marquand was a celebrated author known for his satirical novels about the social elite and his Mr. Moto spy series. Marquand's *The Late George Apley* won a Pulitzer Prize in 1938. The author purchased a home on Kent's Island not far from Bushee's estate in 1935.

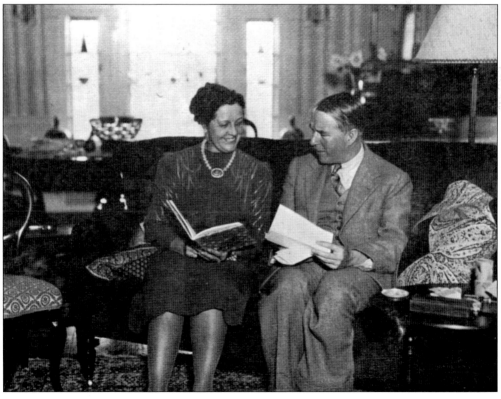

Florence Evans Bushee was a staunch supporter of the arts community and was herself an accomplished pianist in her youth. As an adult, Bushee sponsored musical and theatrical productions in a converted Old Town Hill Farm barn dubbed the Ould Newbury Studio Playhouse. Below, a group poses with a sign announcing the current show, *Petticoat Fever: A Non-Tropical Farce in Three Acts*. This show is a screwball comedy featuring a lonely, bored wireless operator on the coast of Labrador and a couple stranded there by a plane crash. The play was written by Mark Reed in 1927, enjoyed its Broadway debut in 1935, was made into a movie in 1936, and came to the Newbury stage around 1940.

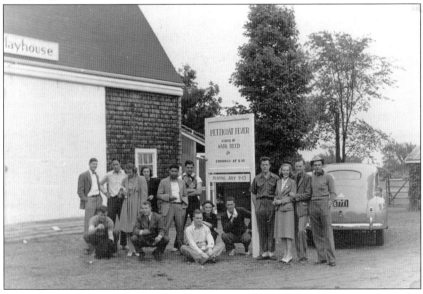

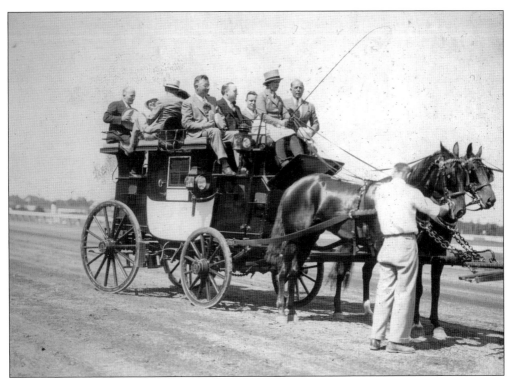

Florence Evans Bushee is seen here preparing to drive her famous coach-and-four with several passengers on board. Bushee used this coach for charity events both locally and across the country. The vehicle was once featured in a Nashville, Tennessee, Red Cross drive and was used by Newburyport's Junior Victory League to sell war bonds and stamps during World War II.

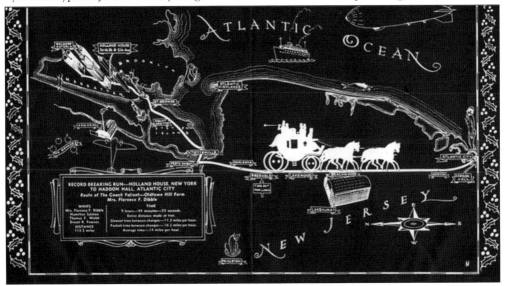

This 1937 Christmas card from Old Town Hill Farm commemorates then–Florence Evans Dibble's record-breaking trip from New York City to the Atlantic City Horse Show earlier that year. The approximately 110-mile trip took just under 10 hours to complete. Seats on this historic ride were auctioned to raise money for charity.

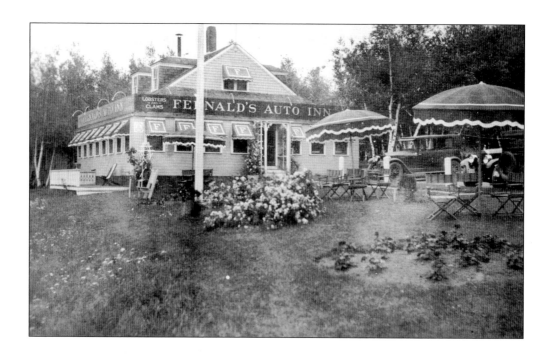

With the advent of car travel in the 1920s, auto inns sprang up across the country to feed a growing demand for tourist lodging. Newbury was no different. Fernald's Auto Inn opened in 1920 where the High Road crosses the Parker River near Newbury's Lower Green. At the time, Route 1A, or the High Road, was a heavily traveled thoroughfare up the northern Massachusetts coast. Fernald's offered tourists comfortable overnight accommodations and a restaurant featuring local fare. The establishment's menu, charmingly shaped like a lobster, outlined the eatery's many seafood dishes. (Both, courtesy of the Fernald family.)

A LA CARTE MENU

Lobster Salad and French Fried Potatoes $1.25

Lobster A La Newburgh and French Fried Potatoes 1.00

Lobster Cocktail and Crackers75

Lobster Stew and Mixed Pickles75

Lobster Stew, Small, Mixed Pickles45

Lobster Salad Sandwich60

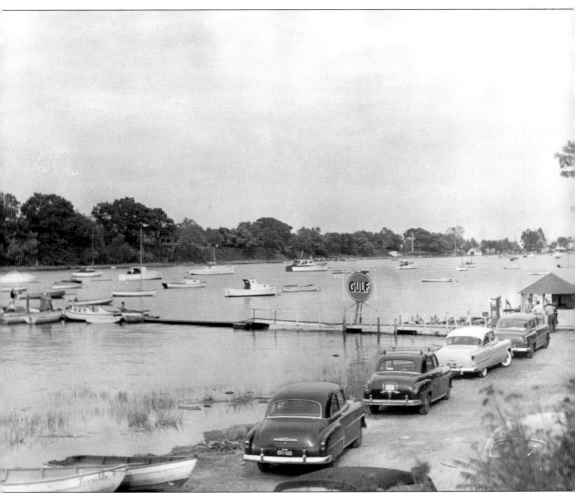

From the 1930s to 1950s, Fernald's adapted to changing American travel patterns. While the Great Depression of the 1930s hindered vacation travel in general, the middle of the decade brought improvements to Newburyport's Route 1, rerouting remaining tourist traffic through Newburyport rather than along Route 1A. In the early 1950s, the construction of Interstate 95 took tourist traffic even further from Fernald's perch on the banks of the Parker River. With fewer passing motorists seeking overnight accommodations, Fernald's closed its auto inn and instead used its riverfront location to offer boat rentals. Residents and tourists alike could rent boats to fish and explore the Parker and Little Rivers, which converge very near Fernald's. In later decades, Fernald's transformed again, becoming a full-service marina that remained in operation into the 21st century. (Courtesy of the Fernald family.)

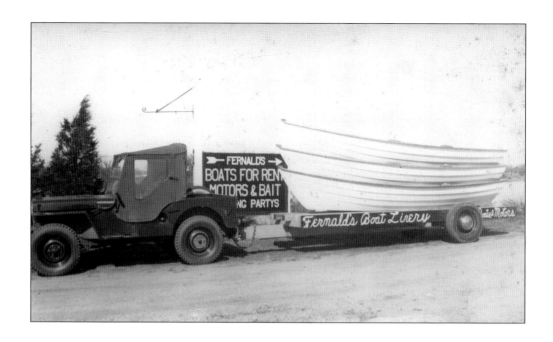

Above, Fernald's offered boats like these for rent. Below, Ida Fernald Blood stands in a gazebo at Fernald's boat launch. Ida married Mervin Blood in 1927, and the 1930 census lists Ida as innkeeper and Mervin as chef at Fernald's Inn. Gazebos like the one pictured here existed at various points along the Parker River, offering day-trippers the opportunity to dock their boats to relax and enjoy the river's scenery. (Both, courtesy of the Fernald family.)

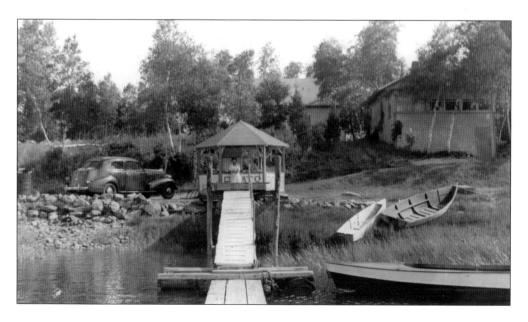

THE MANAGEMENT OF

FERNALD'S AUTO INN

PARKER RIVER

ANNOUNCE

THE OPENING OF THE INN AND GIFT SHOP FOR ITS 13TH SEASON
ON TUESDAY, MARCH 15TH, 1932

SELECTED FOODS — REASONABLE PRICES

WE SPECIALIZE IN STEAK, CHICKEN AND LOBSTER DINNERS.

OUR ENLARGED GIFT SHOP IS UNIQUE.

WE ANTICIPATE THE PLEASURE OF THE EARLY MEETING OF OUR
PAST PATRONS AND MANY NEW ONES.

IDA FERNALD BLOOD

Fernald's announced its 1932 seasonal opening with this attractive card. At the time, the establishment consisted of an inn, restaurant, and gift shop. (Courtesy of the Fernald family.)

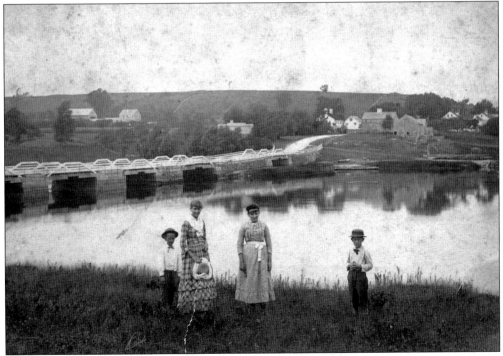

The Parker River Bridge was first laid out in 1758 by shipbuilder Ralph Cross. This c. 1890 view looking northwest shows Old Town Hill. The Dole-Little House is to the north, and the Parker River Pavilion has not yet been built. Note the granite caissons supporting the bridge structure. The bridge has been replaced many times over the centuries; a 1911 structure was replaced in 1935, and the current bridge dates from 2010.

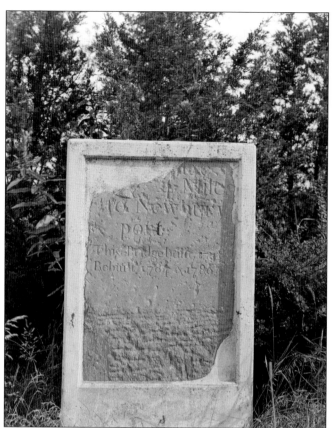

The Parker River Bridge milestone indicates four miles to Newburyport. Frank O. Branzetti was the photographer. (Courtesy of Library of Congress.)

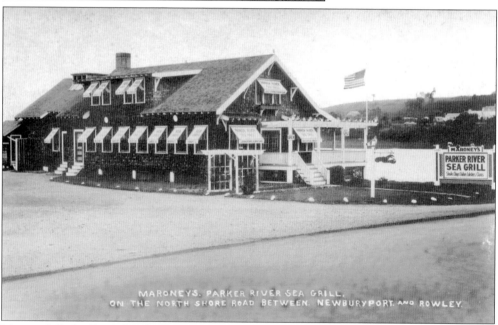

Maroney's Parker River Sea Grill was a popular eatery and was well known for its lobster dinners. It was south of the bridge on the west shore of the river, opposite Fernald's.

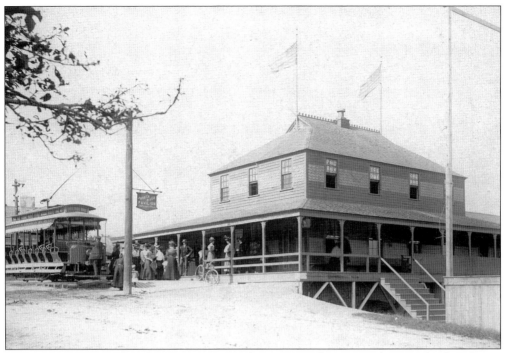

The Parker River Pavilion, later Marston's Pavilion, was on the river at the town landing. It was a popular seafood restaurant in the early 20th century and was advertised in the *Automobile Blue Books*, issued from 1901 to 1921, as specializing in clams and lobsters. The restaurant was run by Fred Marston, known to the locals as "Shorty" due to his extreme height. The restaurant was razed in the 1930s. Note the Dole-Little House directly behind the pavilion.

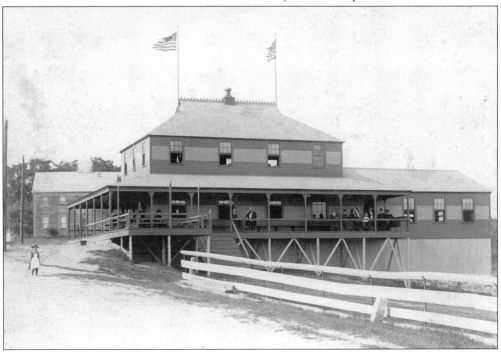

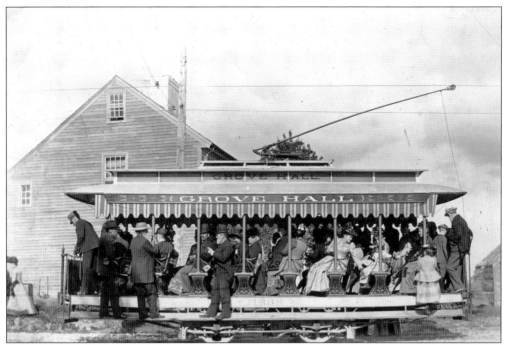

Electric trolley service to the Parker River from Newburyport commenced on July 4, 1891. A week earlier, the Newburyport garage that housed the trolley cars caught fire, destroying many cars and equipment. Replacements were hurriedly leased from the West End Street Railway of Boston, including this trolley still marked "Grove Hall," which made the inaugural trip to the Parker River.

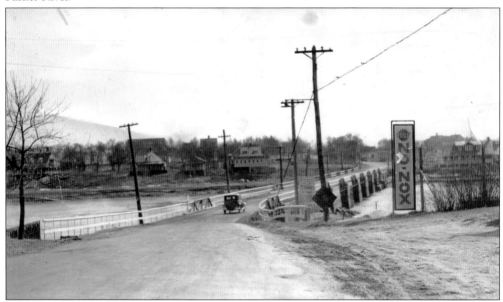

This c. 1930 view of the Parker River was taken from the north side looking toward Rowley. On the right, note the Gulf No-Nox gasoline sign. Gulf-branded gasoline was favored by many early motorists for its quality and consistency. Maroney's Parker River Sea Grill is on the right past the bridge, and Fernald's Auto Inn is on the left.

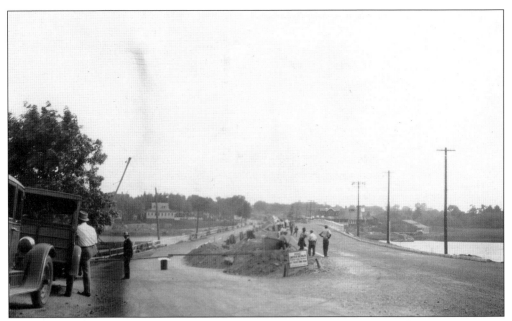

Construction of the new Parker River Bridge in 1935 was of great importance to the community, as the bridge has been the lifeline to communities south since the middle of the 18th century.

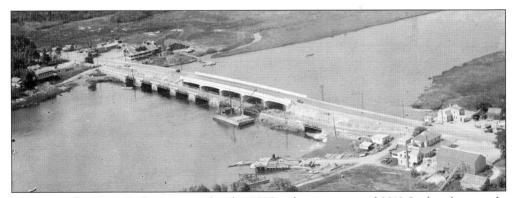

The new Parker River Bridge was completed in 1935 and was in use until 2010. In this photograph, the old bridge, slightly to the east of the new bridge, has not yet been removed.

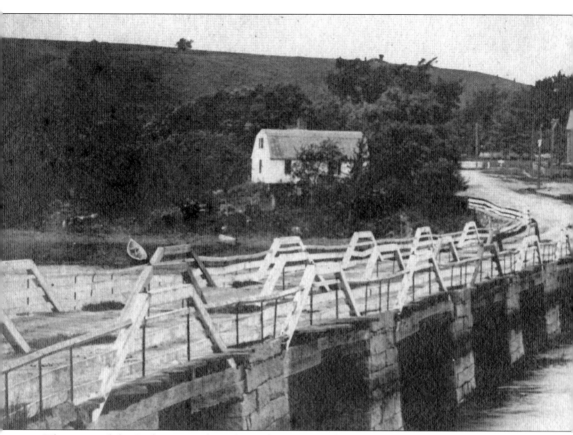

This view of the Parker River dates from about 1890. The pavilion, on the right, advertises its

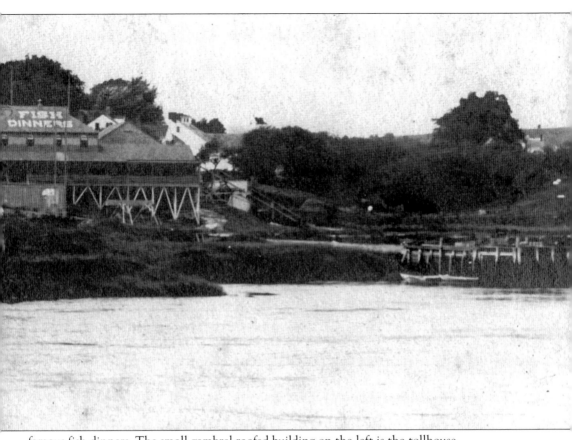

famous fish dinners. The small gambrel-roofed building on the left is the tollhouse.

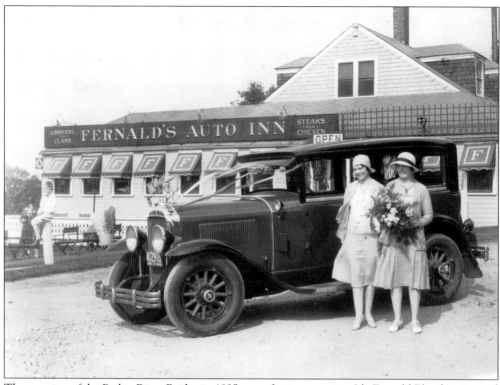

The opening of the Parker River Bridge in 1935 was a festive occasion. Ida Fernald Blood is pictured holding a spray of flowers and posing with a companion. Ida's son, young Howard Benjamin Fernald, known as "Bunny," is seen at left sporting a bow tie. (Courtesy of the Fernald family.)

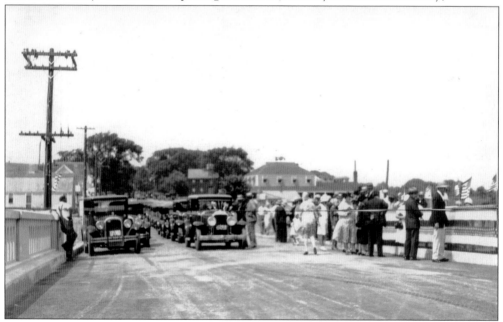

The new bridge opened with great fanfare and crowds gathered around to celebrate. Marston's Parker River Pavilion sports a large lobster advertising sign on its roof.

Eight

THE PARKER RIVER

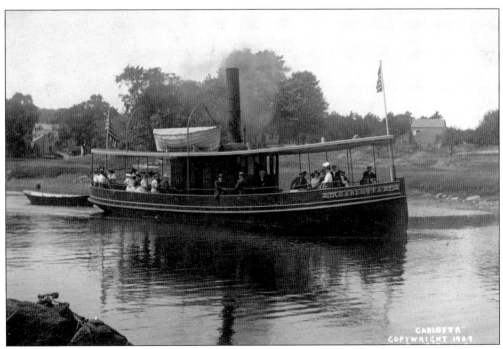

The steamer *Carlotta* took passengers from Ipswich to Old Town and Plum Island. The *Carlotta* was built in 1878 and was in operation for 35 years. It was co-owned by Charles Brown and Nathaniel Burnham. Burnham served as captain and charged 40¢ for a round-trip between Brown's Wharf in Ipswich and the Parker River landing in Old Town.

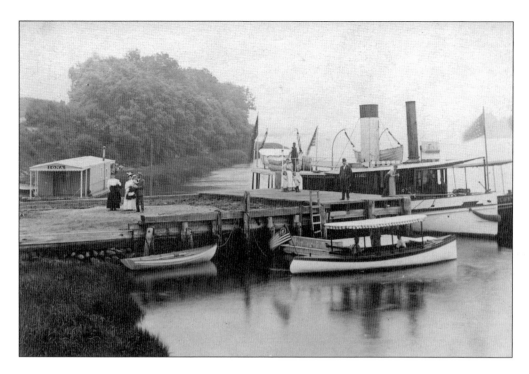

These two views are of the *Cygnet*, the other commercial steamer that plied the waters of the Parker River providing pleasure excursions for residents and visitors alike. In addition to fulfilling this role, the *Cygnet* was also employed in the anniversary festivities for the city of Newburyport in 1901.

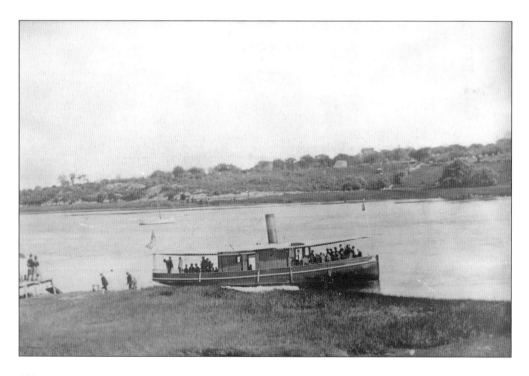

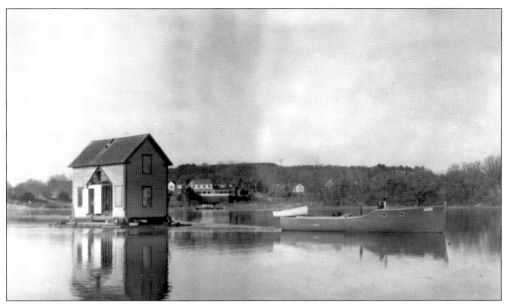

This house is being transported upriver from Grape Island to a new location on Marsh Avenue. The c. 1952 view is looking toward Old Town Hill. (Courtesy of the Fernald family.)

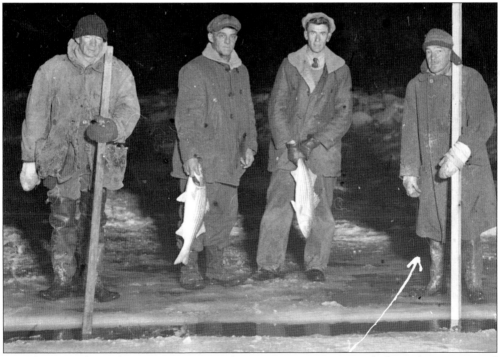

Ice fishing on the Parker River was a popular winter activity, particularly in the area around Thurlow's Bridge.

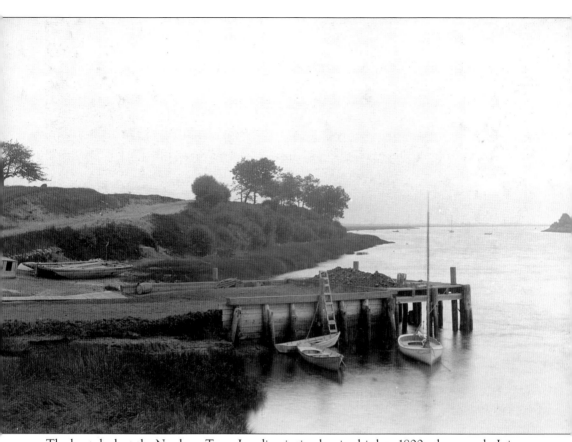

The boat dock at the Newbury Town Landing is timeless in this late-1800s photograph. It is easy to imagine the Pawtuxet Indians here 250 years earlier, when the Parker River was known as the Quascacunquen River.

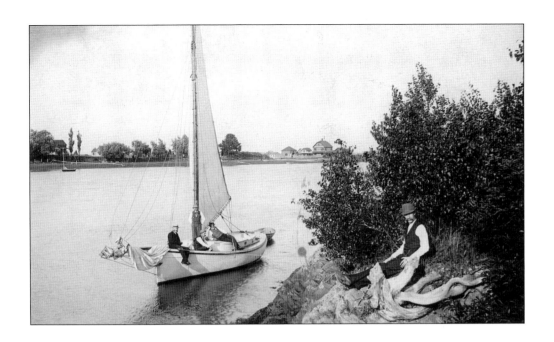

Sailors take a break along the banks of the Parker River across from the town landing. The sea breezes blowing over from Plum Island make this a perfect spot in which to enjoy some of the best that Newbury has to offer.

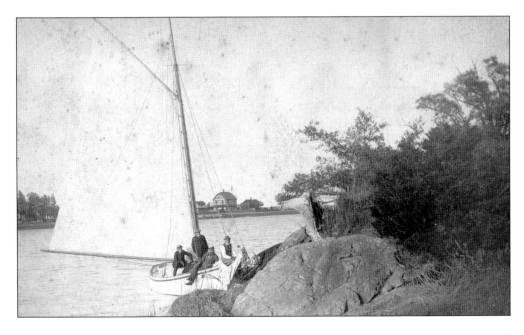

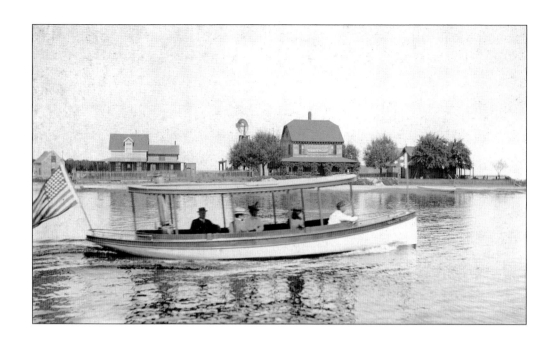

The Parker River has always been popular for boating enthusiasts, whether for sailboats or larger launches. Above, around 1890, a group passes by the landing place of the first settlers. The large cottage on the right bears the name Summers Delight. Below, two boats are seen at sail, while several others lie at anchor.

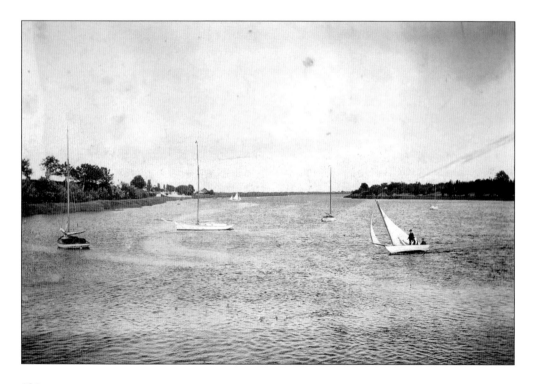

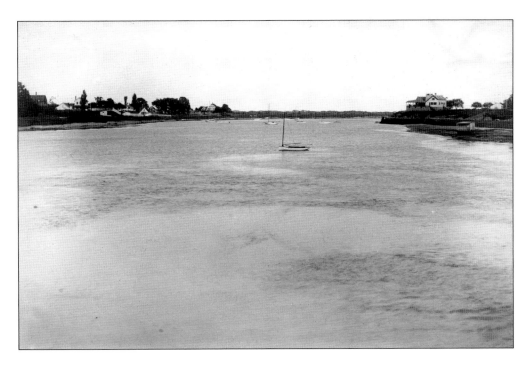

The view above of the Parker River looking east toward Plum Island shows the Oldtown Country Club on the right. Below, the Oldtown Country Club is seen from the south side of the Parker River. As befits its name, the club overlooks the landing site of the first settlers across the Parker River on what is now Cottage Road. (Below, courtesy of the Fernald family.)

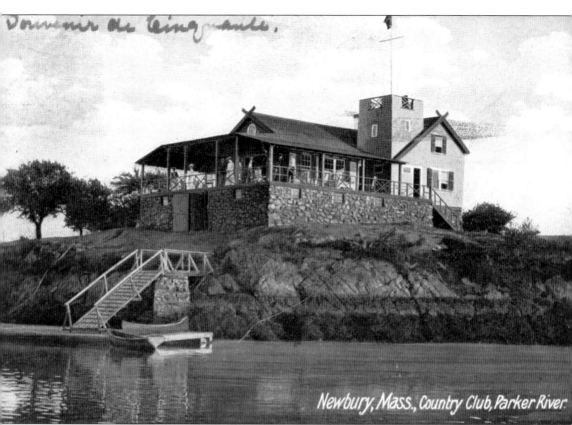

Souvenir de Cinquante,

Newbury, Mass., Country Club, Parker River.

Around 1900, members of the Dalton Club, a men's social group based in Newburyport, approached Charles M. Lunt about building a summer headquarters on Lunt's land along the Parker River. Lunt agreed to a five-year lease of his land with renewal privileges, and the Oldtown Country Club was constructed in 1902. This upscale club was used by members primarily for tennis and boating, though a small golf course did exist for a few of the club's early seasons. A June 1, 1903, article in the *Newburyport Daily News* outlined the club's many new amenities for the season, including a bandstand, new lockers, clay pigeons and a "shooting apparatus," a system of electric bells (presumably call bells), and sleeping quarters on the second floor. The building pictured here burned in 1964 and was rebuilt in 1965. (Courtesy of the Fernald family.)

Nine

PLUM ISLAND

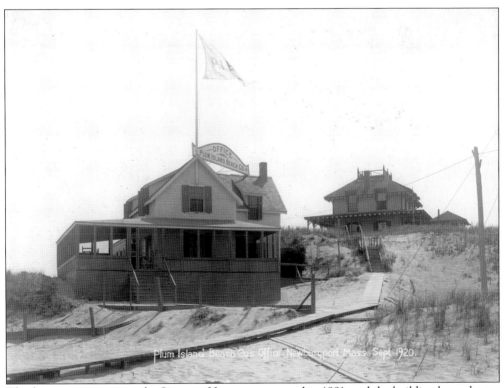

Plum Island Beach Co's. Office. Newburyport, Mass. Sept. 1920.

The first summer cottage, the Simpson House, was erected in 1881, and the building boom began in earnest in 1886.

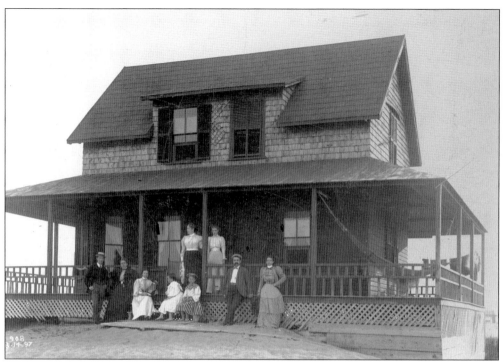

As the island became more inhabited and many more cottages were built, it became fashionable for residents to name their ocean-side retreats. Miramar Cottage (above) was photographed by John White Winder. Mother Hubbard Cottage (below), although not so grand, is a perfect retreat for sporting enthusiasts.

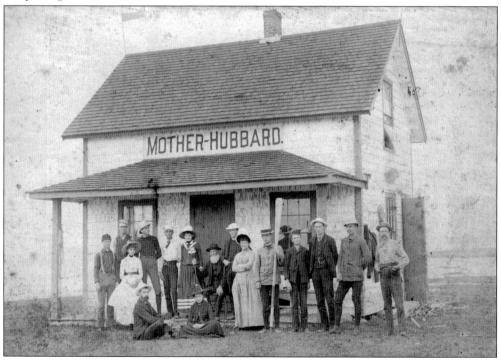

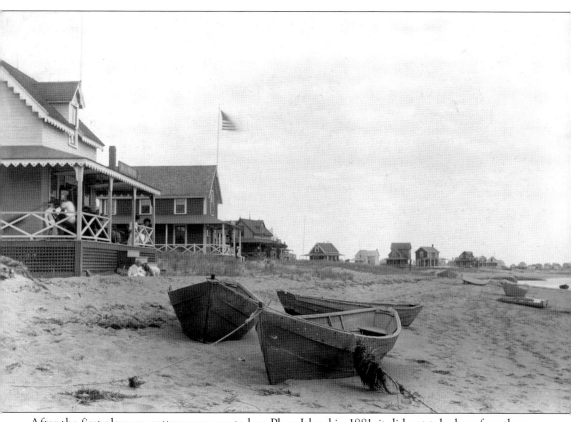

After the first pleasure cottage was erected on Plum Island in 1881, it did not take long for other cottages to crop up along the shoreline.

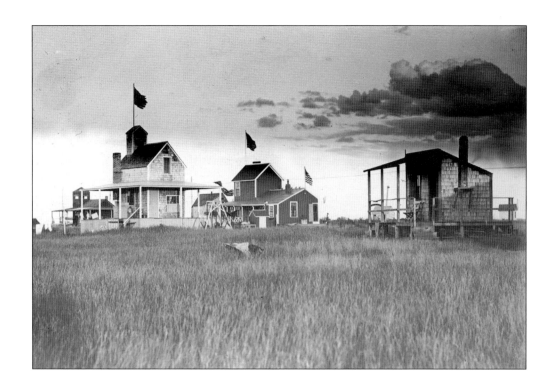

Early cottages on Plum Island were somewhat rustic. In order to take full advantage of the shoreline location, most cottages boasted large covered porches for enjoying ocean views and breezes.

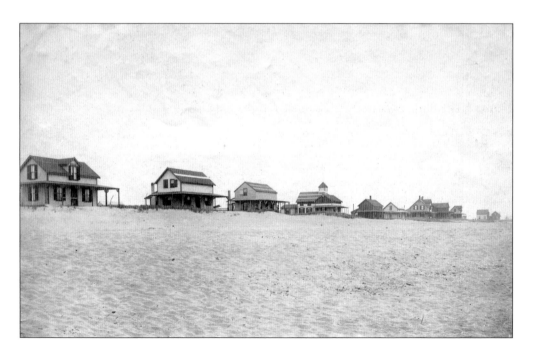

The Noyes family goes back to the days of the first settlers in Newbury. Here in 1890, later generations gather at their cottage on Plum Island. From left to right are Harry V. Noyes, S. Henry Noyes, Harlan E. Noyes, Marie Farrar, Maggie C., Herbert Farrar, Fred S. Noyes, Sarah J. Noyes, Ella W. Noyes holding Howard, and George Farrar.

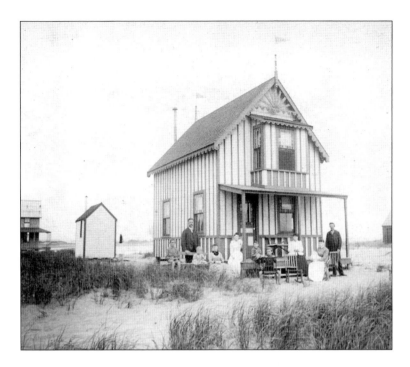

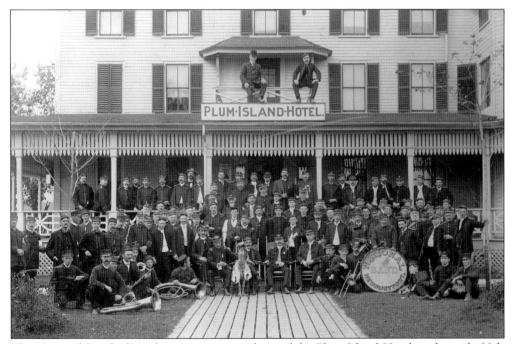

The National Band of Newburyport poses in front of the Plum Island Hotel in the early 20th century. In the front row, two men hold on to a goat, the band's mascot. Waterfront concerts have always been popular summer events in Newbury and Newburyport.

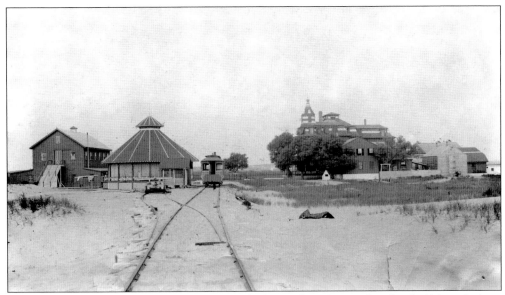

The Plum Island Hotel, pictured in 1877, was the largest hostelry on the island. Although there were numerous landlords, the hotel became best known under Capt. Nathaniel Brown in the 1830s and under William H. Thompson in the mid-19th century. The cuisine was highly esteemed, and game dinners were a favorite. Over the decades, the hotel was remodeled and updated. Sadly, it was destroyed by fire in May 1914.

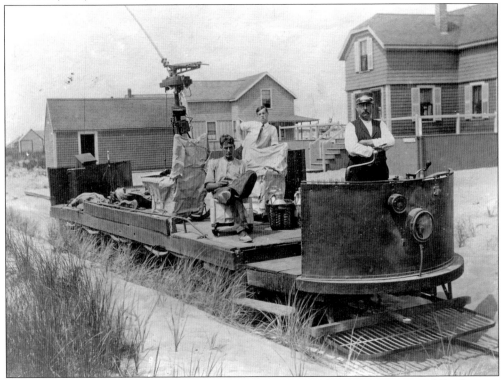

Ice, milk, and other deliveries to Plum Island were made by electric car. Driver Ed Fowler is at the helm.

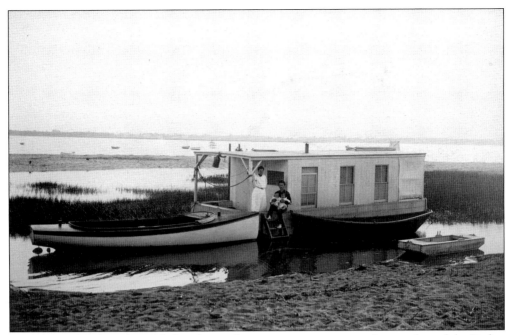

This young family with two babies has a pleasant mooring spot on the marshes of the Parker River near Plum Island. Houseboats on the river have always been popular and continue to be so today all the way to Sandy Point.

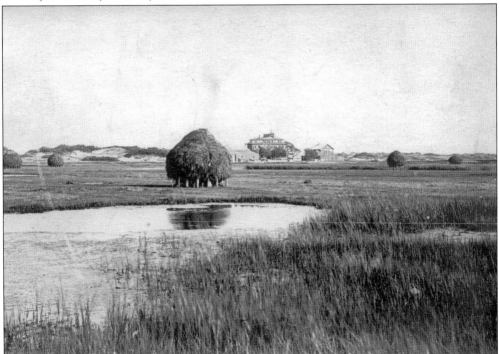

Plum Island has long been a destination for both business and pleasure. Here, the haystacks in the foreground illustrate the island's agricultural use, while the Plum Island Hotel, seen in the distance, is a reminder of the recreation enjoyed here by many.

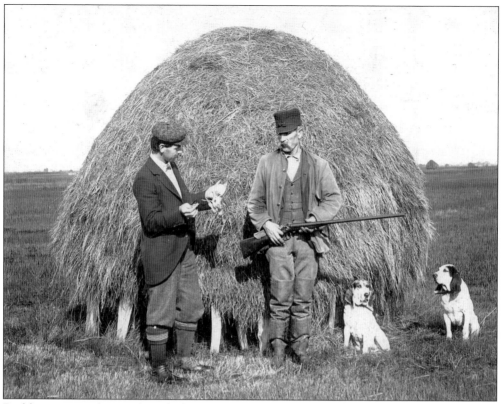

Bird hunting on the marsh and Plum Island was a popular pastime, and migratory waterfowl were plentiful. The abundance of game also attracted sportsmen to the area throughout the 19th century and into the 20th century. Many of the gunners and hunters stayed at the Plum Island Hotel, while others had small cottages and duck blinds on the marshes.

This winter view on Plum Island shows bird hunters in sneak floats, fabric-covered vessels that move silently in the water so the wildlife will not be alerted to a hunter's approach.

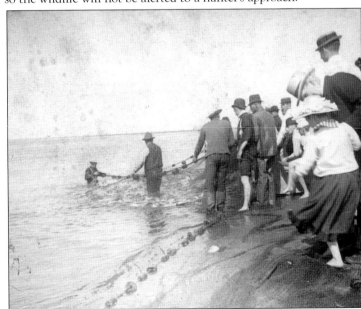

This enthusiastic group of Plum Islanders is dragging a fishing net to catch bait fish. This process, called seining, can be done from shore, as shown here, or from a boat.

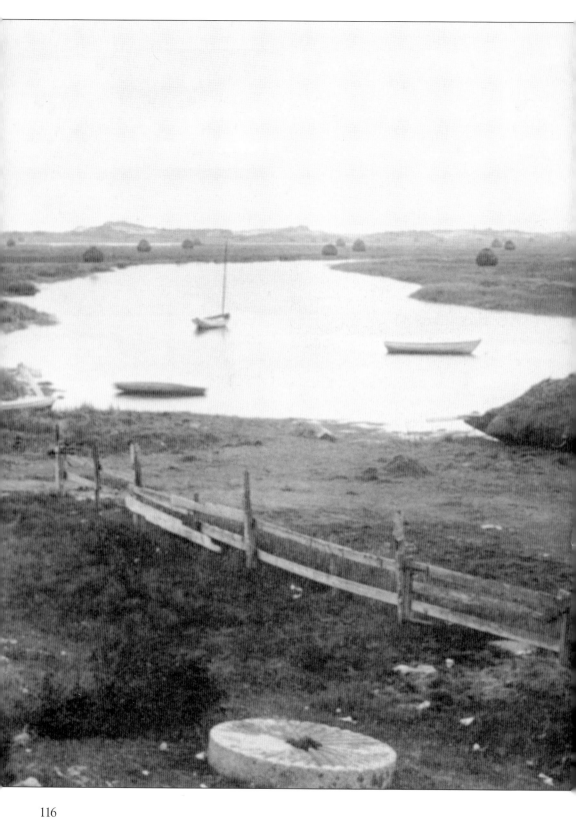

This view is of Pine Island to High Sandy, the highest point on Plum Island. Of particular interest is the large millstone in the foreground of the photograph. The gundalow, a flat-bottomed boat, has been piled with harvested salt marsh hay. This type of craft could move easily in the shallow marsh waters. The gundalows, especially useful during high tides, were then rowed to a docking area and the hay loaded on to farm wagons.

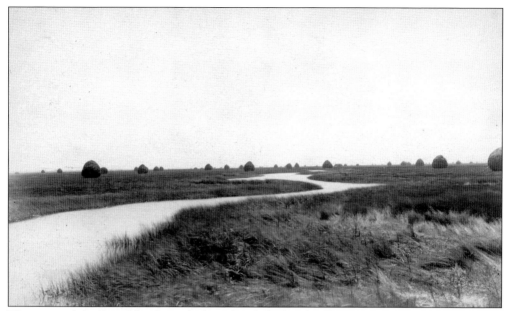

This view of the Pine Island marsh dotted with haystacks illustrates a centuries-old trade in Newbury. During the area's early settlement, salt marsh hay was used for insulation, roofing, and livestock feeding and bedding. Today, salt marsh hay is used primarily for mulch.

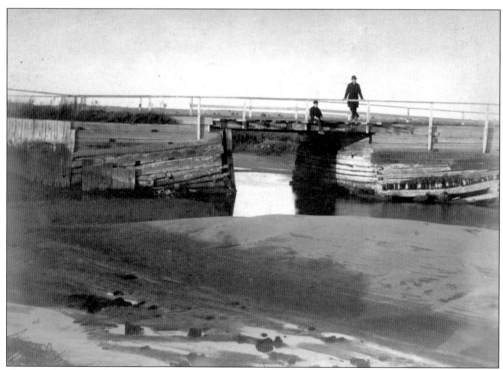

Plum Bush consisted of a settlement of hunting blinds and cabins on the north side of Plum Island Turnpike. The Plum Bush Bridge is pictured here.

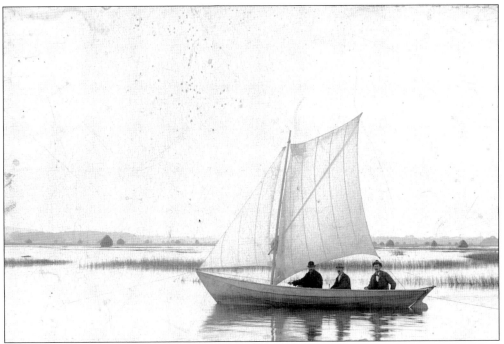

Sailing has long been a favorite pastime on Plum Island's tidal creeks and rivers. This trio of well-dressed gentlemen appears to be enjoying a relaxing outing.

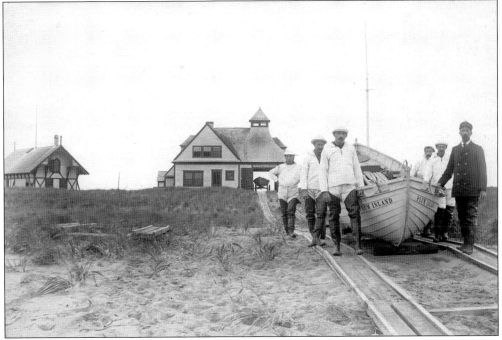

In 1874, Plum Island welcomed its first US Life-Saving station, pictured above at left. This building was first erected at Sandy Beach on the southern part of Plum Island and was moved to the northern end of the island in 1881. In 1890, it was supplemented by a new building, seen at right. The old building was then used as a workshop and storehouse.

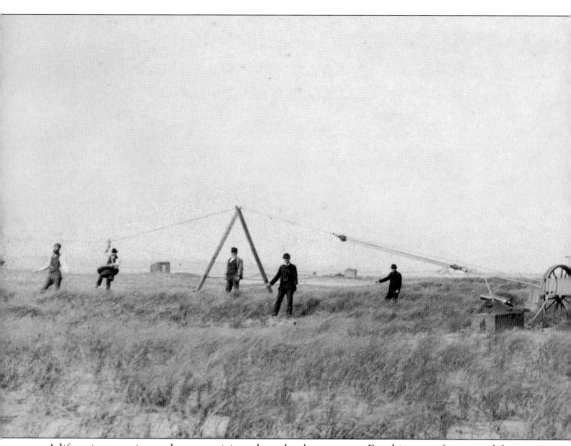

A lifesaving crew is seen here practicing a breeches buoy rescue. For this type of rescue, a lifesaving crew on land would use a Lyle gun to shoot a length of rope to a ship in distress. The crew onboard the ship would then secure the rope, and lifesavers on shore would attach a pulley and flotation device with leg harnesses resembling breeches. The lifesavers kept the apparatus out of the water

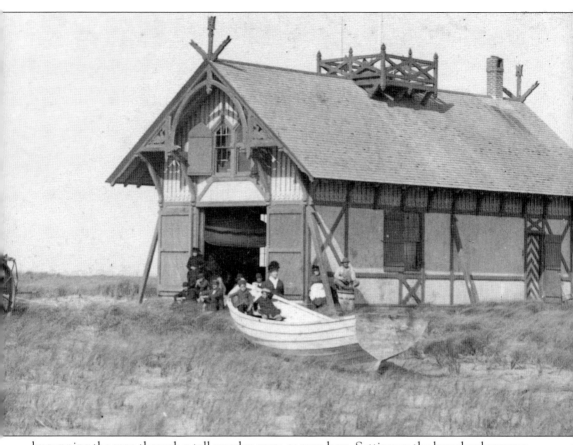

by running the rope through a tall wooden prop, as seen here. Setting up the breeches buoy was difficult and dangerous, but once it was assembled, a ship's crew and passengers could be brought to safety one-by-one in zip-line fashion. The technique was effective but tricky, and lifesaving teams practiced it often on land.

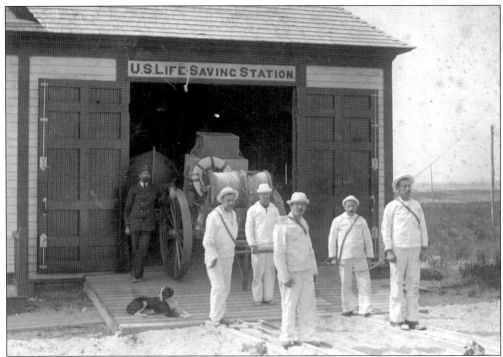

As seen above, lifesaving crews used a rail system to move supplies from their station across the sandy beach to the water's edge. A surfboat is visible behind the laden wagon. Below, the crew rows a surfboat to shore; this type of boat was used for most rescue operations. A surfboat is designed to be launched into stormy seas directly from the beach. Both the bow and the stern of the surfboat are pointed to lend the boat extra stability facing heavy waves, particularly from the back when returning to shore.

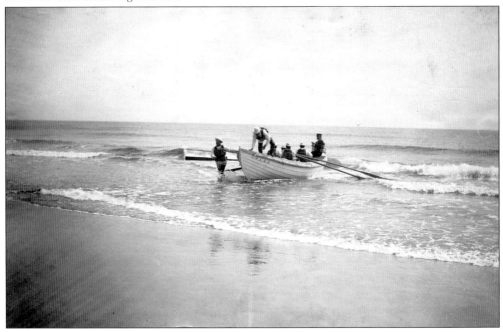

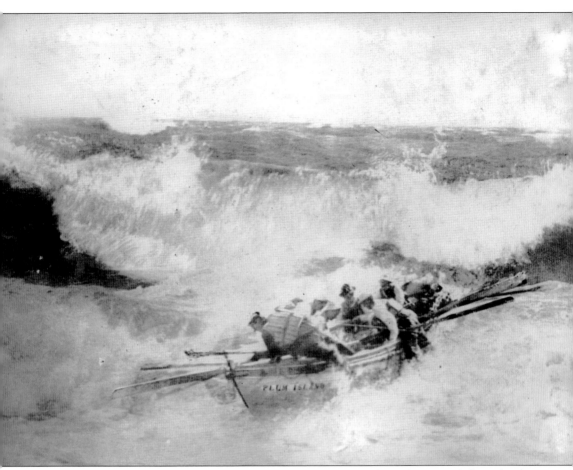

On August 11, 1898, the sloop *Wayward* was dismasted in heavy winds off the coast of Plum Island. A crew from the Plum Island Life-Saving Station rowed for an hour to reach the vessel, provide each crew member with a life jacket, and transport the crew from the sinking ship to a steam tugboat, which took them to safety. The 1898 *Annual Report of the Operations of the United States Life-Saving Service* noted that "it was a very difficult job, as [the sloop's crew was] much frightened and all seasick." The sloop drifted ashore overnight, where Life-Saving Service members collected the property on board and ungrounded the vessel at high tide. They then took it to Newburyport for repairs. Part of the lifesaving crew's daring rescue mission is captured here on film.

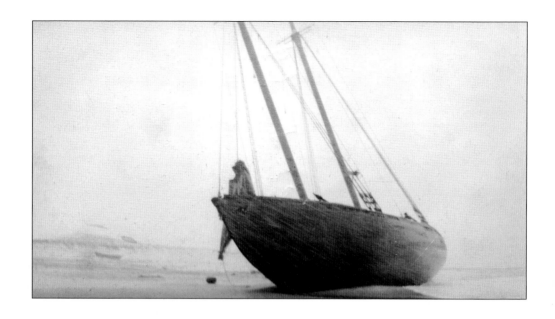

The *Ingomar* was a 116-foot fishing schooner out of Gloucester that was built in 1904. It was wrecked on Plum Island in February 1936 carrying a cargo of 50,000 pounds of fish. The crew of 21 men survived.

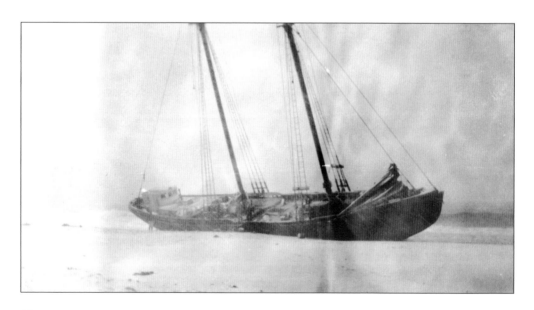

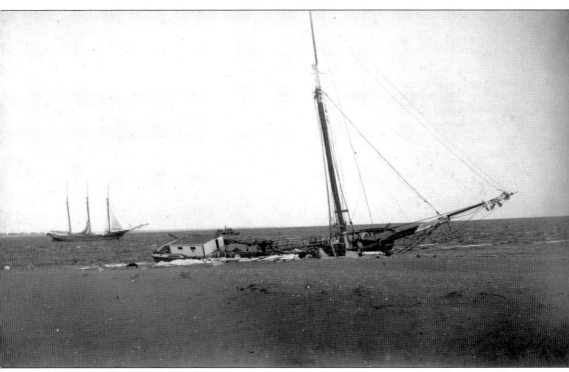

The schooner *Carrie S. Spofford* was wrecked in November 1886 just north of the Plum Island Life-Saving Station. Through the use of the breeches buoy, John Parsons, James Van Buren, John Sargent, Phillip Creasey, and Arthur Huse were successful in rescuing the captain, the crew, and one passenger. The vessel was left on the beach to be ravaged by the perpetual forces of wind and water.

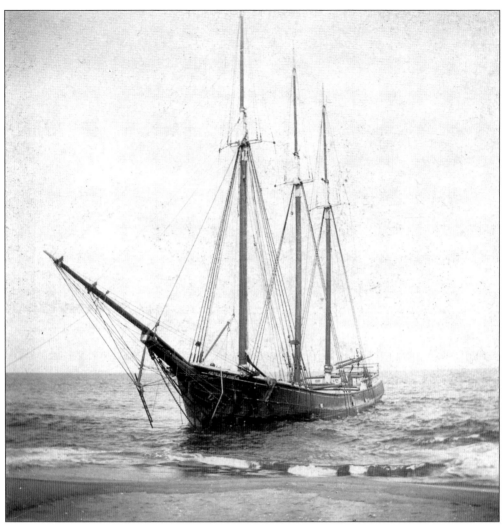

The three-masted schooner *Abbie and Eva Hooper* (seen in 1895) was carrying a cargo of coal in July 1895 from Philadelphia bound for Amesbury, Massachusetts, when it was stranded on Plum Island near the life-saving station. The officers and crew were rescued and the cargo secured. About 10 days later, it was hauled to Boston for repairs. In November 1911, on a voyage from New Jersey to Maine, the schooner was wrecked in Vineyard Sound.

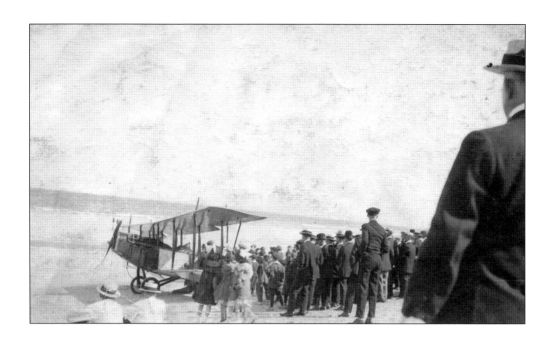

Pioneers of New England aviation W. Starling Burgess and Augustus M. Herring made national news between April and July 1910 with biplane test flights on the dunes and marshes of Plum Island. The events were a tremendous step forward in American aviation, and the residents of Plum Island and neighboring communities caught the bug. In June and November 1921, people gather once again to see these fabulous events.

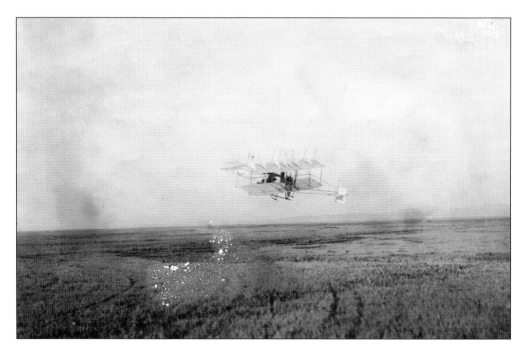

Discover Thousands of Local History Books
Featuring Millions of Vintage Images

Arcadia Publishing, the leading local history publisher in the United States, is committed to making history accessible and meaningful through publishing books that celebrate and preserve the heritage of America's people and places.

Find more books like this at
www.arcadiapublishing.com

Search for your hometown history, your old stomping grounds, and even your favorite sports team.

Consistent with our mission to preserve history on a local level, this book was printed in South Carolina on American-made paper and manufactured entirely in the United States. Products carrying the accredited Forest Stewardship Council (FSC) label are printed on 100 percent FSC-certified paper.